PAINTING light
WITH COLORED PENCIL

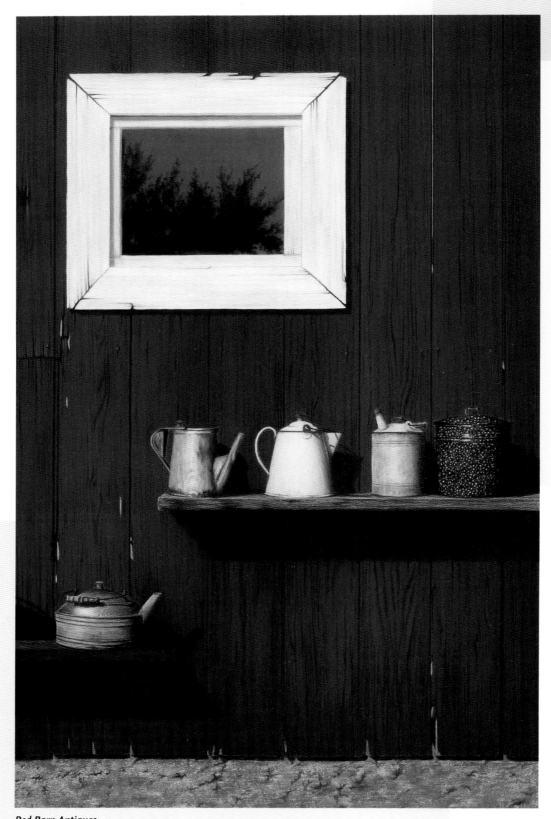

Red Barn Antiques
Colored pencil on Strathmore 500 Series, regular surface
12½" × 20" (32cm × 51cm)
Private collection

PAINTING light
WITH COLORED PENCIL

CECILE BAIRD

NORTH LIGHT BOOKS
CINCINNATI, OHIO
www.artistsnetwork.com

ABOUT THE AUTHOR

Cecile Baird received B.F.A. and M.A. degrees in graphic design from Ohio State University. After working as a designer for several years in St. Louis and Los Angeles, Cecile returned to Ohio to open her own business designing and selling a canine collectible line to gift stores all over the country.

While her business continues, Cecile has turned her talents to painting. Working in colored pencil and oil, she has developed a realistic style that captures the drama, beauty and simplicity of everyday objects. Cecile's paintings draw the viewer back again and again with her strong use of composition and lighting.

Cecile is a signature member of the Colored Pencil Society of America. Her colored pencil paintings have received numerous regional, national and international awards. Her work has been published in *The Artist's Magazine, International Artist* and *North Light* magazine, and was featured in *American Artist* magazine in April 2003. Prints of several of Cecile's paintings are now available from Applejack Art Partners in Manchester, Vermont.

To contact her or see more artwork visit her website at www.cecilebairdart.com.

Painting Light With Colored Pencil. Copyright © 2005 by Cecile Baird. Manufactured in China. All rights reserved. No part of this book may be reproduced in any form or by any electronic or mechanical means including information storage and retrieval systems without permission in writing from the publisher, except by a reviewer who may quote brief passages in a review. Published by North Light Books, an imprint of F+W Publications, Inc., 4700 East Galbraith Road, Cincinnati, Ohio, 45236. (800) 289-0963. First Edition.

Other fine North Light Books are available from your local bookstore, art supply store or direct from the publisher.

09 08 07 06 05 5 4 3 2 1

Library of Congress Cataloging in Publication Data
Baird, Cecile, 1945-
 Painting light with colored pencil / Cecile Baird.—
1st ed.
 p. cm
 Includes index.
 ISBN 1-58180-530-6 (hc : alk. paper)
 1. Colored pencil drawing--Technique. 2. Light in art. I. Title.

NC892.B35 2005
741.2'4—dc22 2004058343

Edited by Mona Michael and Bethe Ferguson
Designed by Karla Baker
Layout by Kathy Gardner
Production coordinated by Mark Griffin

METRIC CONVERSION CHART

To convert	to	multiply by
Inches	Centimeters	2.54
Centimeters	Inches	0.4
Feet	Centimeters	30.5
Centimeters	Feet	0.03
Yards	Meters	0.9
Meters	Yards	1.1
Sq. Inches	Sq. Centimeters	6.45
Sq. Centimeters	Sq. Inches	0.16
Sq. Feet	Sq. Meters	0.09
Sq. Meters	Sq. Feet	10.8
Sq. Yards	Sq. Meters	0.8
Sq. Meters	Sq. Yards	1.2
Pounds	Kilograms	0.45
Kilograms	Pounds	2.2
Ounces	Grams	28.3
Grams	Ounces	0.035

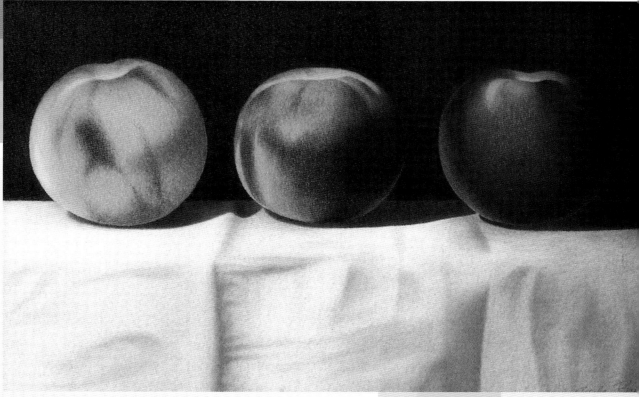

Three Peaches
Colored pencil on Strathmore 500 Series, regular surface
7" × 12" (18cm × 30cm)
Private collection

ACKNOWLEDGMENTS

This book could not have happened without my family and friends.
A special thank you to:

- My brother, also a fellow artist, who spurs me on with love and friendly competition. Top this one, Raymond!
- Gail, Dianne and Susan, who kept the collectible business going while I took off so much time to work on the book. I couldn't have done it without you.
- The Thursday Night Art Ladies who were always only too happy to critique the art for the book. Your insights were invaluable, but more importantly, your friendship is a special gift that I treasure.
- Ann Kullberg, who so generously suggested me for this book.
- And to my editors, Bethe Ferguson, who got me started and Mona Michael, who pulled all my work into a cohesive, comprehensible and beautiful book. You know how to make me look good.

DEDICATION

This book is dedicated to my mother and father who always thought I could do anything. They always encouraged my creativity and never told me to do something practical. Thanks for your love, support and artistic genes.

TABLE OF CONTENTS

INTRODUCTION 8

1 INSPIRATION, COMPOSITION & LIGHTING 10

Paint Subjects You Love

Create Good Composition

Choose the Right Lighting

Using Artificial Lighting

Using Natural Lighting

Still-Life Photographs Add Convenience

2 TOOLS & TECHNIQUES FOR PAINTING LIGHT 26

Paper

Pencils

Accessories

Create a Line Drawing

Drawing From Photographs

Transfer Drawing to Your Final Paper

How to Use Colored Pencils

Get Great, Fast Results With Solvents

Use Value Generously

Discover Color

Layer Color for Luminosity

Layer Complementary Colors

Place Complements Side by Side

3 CREATE FRUIT & FLOWERS THAT GLOW 46

STEP-BY-STEP DEMONSTRATIONS

Kiwi Fruit

Cantaloupe

Apple With Crock

Money Plant

Orchid

Rose

Autumn Leaves

Shiny Green Leaf

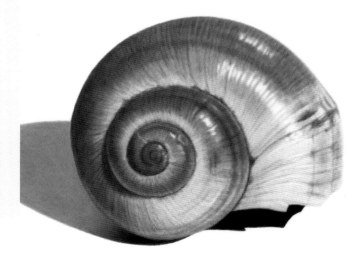

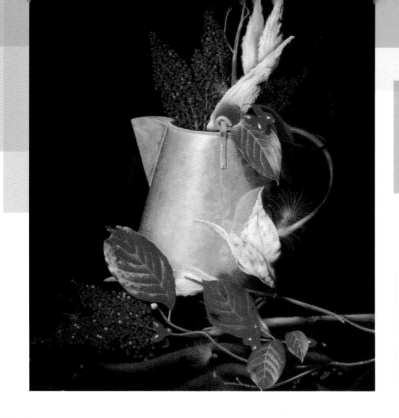

5 BRING TEXTURES TO LIFE 86

STEP-BY-STEP DEMONSTRATIONS

Copper Cup

Cast Iron Kettle

Freshwater Shell

Weathered Wood Box

Velvet Drape

Linen Tablecloth

4 CAPTURE LIGHT & WATER 72

STEP-BY-STEP DEMONSTRATIONS

Capture Candlelight

Oil Lamp

Cobalt Blue Glass

Spilled Water

Water Fountain

6 PAINT THE TOTAL PICTURE 102

STEP-BY-STEP DEMONSTRATIONS

Combine Textures in Soft Light

Paint Light-Filled Surfaces With Texture

CONCLUSION 126
INDEX 127

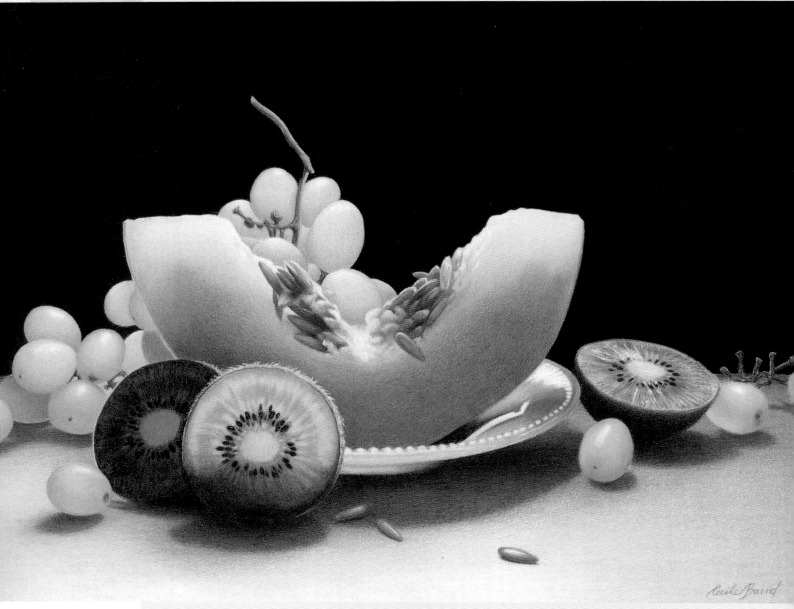

Shades of Green
Colored pencil on Strathmore 500 Series, regular surface
9" × 12" (23cm × 30cm)
Private collection

Introduction

My two main objectives with this book are to convey my excitement about colored pencils, and to share my techniques for capturing light using this simple medium. Whether you are an oil painter, a watercolorist, a pastel artist, or are still looking for the right medium for you, I hope you will be inspired to try colored pencils. If you're already an experienced colored pencil artist, I encourage you to explore the potential of this medium to achieve luminescence equal to or better than any other medium used in art today.

Through the lessons in this book, you will learn how to create any look you desire with colored pencil. Your work can be soft like the impressionists' or detailed and realistic like the Old Masters'. You will learn how to make deep rich darks and glowing colors that surpass even oil.

For centuries artists have been intrigued by light and tried to capture it in their paintings. I am no exception. No other medium can re-create light like colored pencils. Viewers often feel as though they can smell the rose, taste the juicy melon or feel the warmth of a candle flame.

While my methods are not speedy, achieving a painterly look is not difficult and is no more time-consuming than oil painting. And no other medium is more convenient. Most other mediums require lots of preparation and cleanup every time you work. With colored pencils you just pick up your pencil and start. When you are finished, just get up and go. No mess! No fuss!

Before you begin your colored pencil work, you need two things: subjects to paint and basic drawing skills. I'll talk about finding ideas and inspiration, and how to turn those into great still-life setups. And while this book is not about learning how to draw, I will discuss the basics and show you how to use them in your work. Drawing is the foundation upon which you build to become a good artist. There are many fine drawing books available from North Light Books that will help you improve your work.

Although I hope this book is beautiful, it's a workbook as well. You must pick up your pencils and try it yourself. Follow the step-by-step demonstrations and you will quickly learn how to achieve the look you want.

Study the techniques and principles that work for me and use them to create your own unique look. Learning to use colored pencil techniques is important, but your painting has to connect to the viewer in an emotional way. Paint what you love and transfer your emotion to your artwork. You'll be creating stunning paintings on your own in no time.

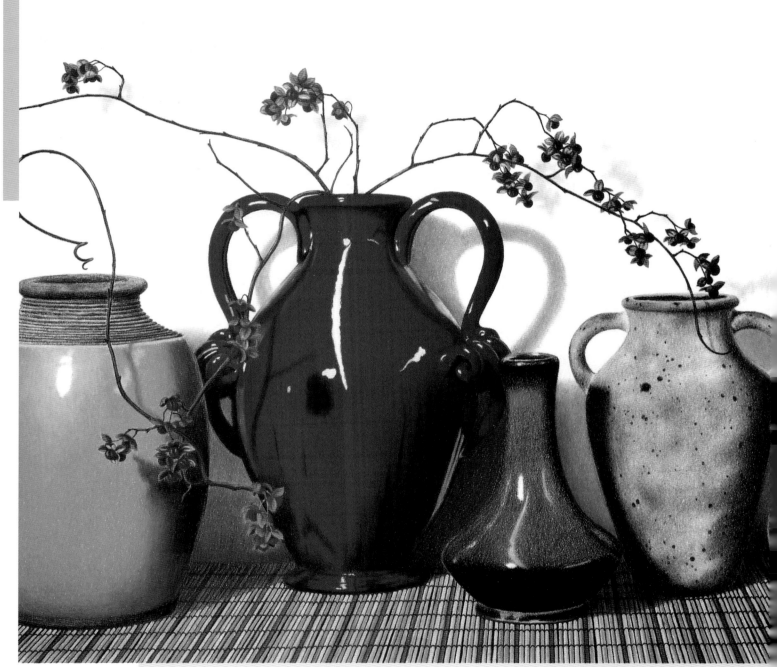

Vases and Vines
Colored pencil on white Stonehenge paper
10" × 16" (25cm × 41cm)
Collection of the artist

chapter one

INSPIRATION, COMPOSITION & LIGHTING

Every successful painting begins with an idea. Whether you find inspiration in a bowl of fruit or the morning light shining through your window, painting subjects exist all around you.

Understanding a few basics of composition will help you explore the possibilities of your ideas and experiment with different still-life setups with confidence. After that, knowledge of a few lighting techniques and some basic photography skills are all you need to take advantage of that perfect still-life arrangement and begin creating beautiful, light-filled colored pencil paintings.

Paint Subjects You Love

I am lucky. My world is full of inspiration: the mist rising off a pond full of cranes; a row of old oil cans; light shining through the delicate petals of a rose. There is no a lack of subject matter for my paintings. I will never have enough time to draw all of the ideas I see.

Artists are drawn to different subjects; some to animals, others to landscapes. Some have to paint a little of everything. I am drawn to the still life and think there is nothing more beautiful than a simple piece of fruit.

Setting up a still life is one of the fun aspects of painting. Combine interesting objects into something you would like to share with others. Look for ways to make even the most ordinary objects exciting. In regards to my paintings, a viewer once said to me, "Who knew that three pears could be so interesting!" That's one of my all-time favorite compliments.

If you paint subjects that you love, your enthusiasm will transfer to your art. The color of a piece of fruit, the texture of a basket or the shape of a tea kettle can be the inspiration for a still life.

Have a camera on hand as you look for inspiration for your work. Keep in mind some of the components that make up a successful painting:

- Texture
- Color
- Shape
- Repetition
- Light
- Reflections
- Shadows

Looking for these components in your subjects before you begin to paint will help you to arrange a pleasing composition.

TEXTURE
Look for interesting and contrasting textures as you assemble your still-life setups. You may use contrasting textures, such as the strawberries versus the satin drape; textures that are similar, like the baskets; or natural, off-beat textures, such as the seashell.

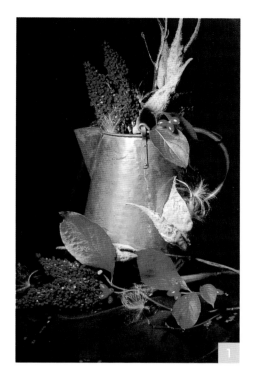

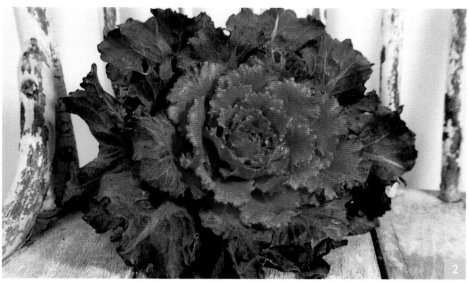

COLOR

In photo 1 the autumn leaves and berries harmonize beautifully with the copper kettle to make a breathtaking display of vibrant color. Use *analogous colors*—colors next to each other on the color wheel—to create a sense of harmony in a painting. Set the colors against a dark background to emphasize the colors even more. This is the photo reference used for the painting *Autumn* on page 86. On the other hand, *complementary colors*—colors opposite each other on the color wheel—can be very dramatic and pleasing as well. This is evident in photo 2 where the complementary color combination of brilliant pink and dark blue-green is the first thing that your eye sees when you look at the picture.

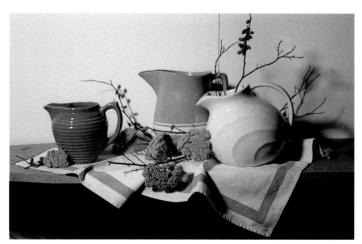

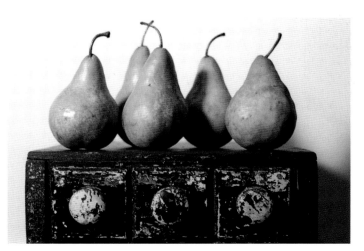

SHAPE

This still-life setup was inspired by the shapes of the pitchers. Look for objects to combine that share shape characteristics. Each pitcher has a spout and a handle, yet each has its own unique shape as well.

REPETITION

Repetition of objects, shapes and colors in a painting are tools that you can use to develop paintings that have a sense of harmony and balance. The repetition can be small and subtle or it can be the dominant theme of the painting as in this setup.

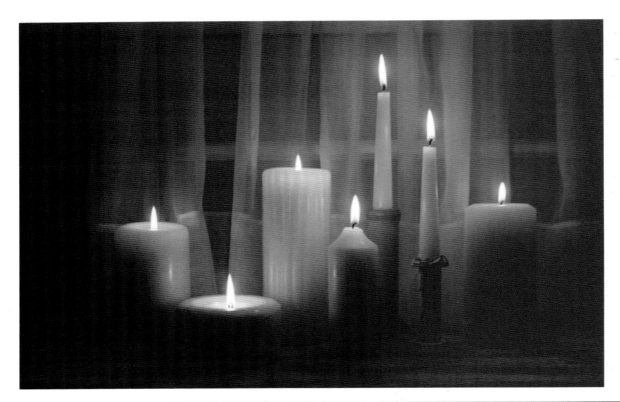

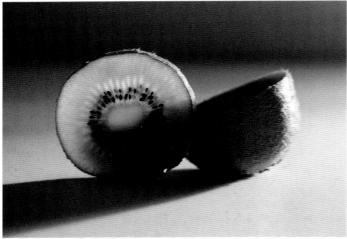

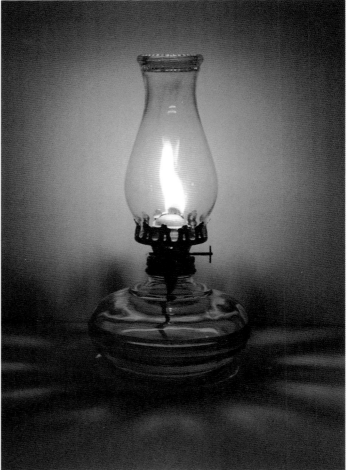

LIGHT

Light is a part of every painting, but it can also be used as the main subject. As you consider setups for your paintings, think about how you might manipulate the light. Use candlelight to unify the color palette, cast a glow over the entire painting, and set a mood. Take advantage of the pattern of shadows cast by the flame of an oil lamp. Use backlighting to affect the shimmer of translucence like with the kiwi. Light can allow you to view an object in an entirely different way.

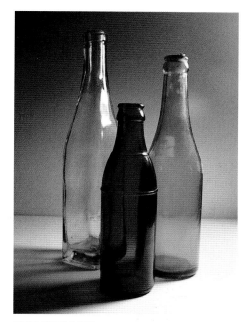

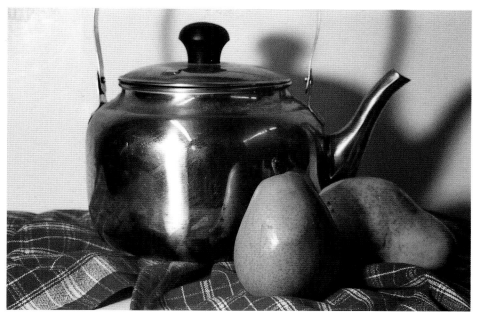

REFLECTIONS

When light passes through clear objects, it reflects any colors in the objects. Light shining through these colored glass bottles spreads the color of each bottle across the surface of the table. Shiny surfaces pick up reflections of the objects around them, just like the pears reflected on the kettle.

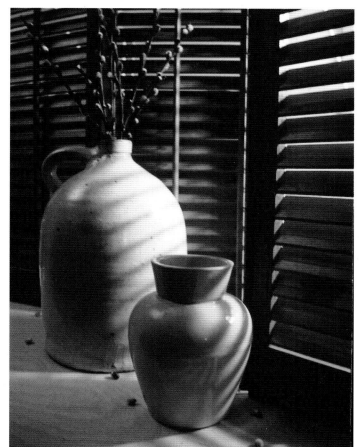

SHADOWS

Shadows help shape objects and add depth and dimension. They can also add drama or even be the main subject of the painting. The light streaming through the shutters onto the vases in this setup creates patterns that mimic the shutters and direct the eye around the image.

Create Good Composition

I have never forgotten this statement by a judge at an art show: you can have a successful painting with good composition and less than perfect technique, but you cannot have a successful painting with great technique and poor composition. Many people struggle with composition. Some seem to have an innate sense of composition while others need guidelines to follow.

What exactly is composition? Simply, it's how the ingredients fit together to create your painting. In a still-life painting composition involves selecting objects to express your idea, arranging those objects within the borders of your painting, then lighting them. Composition should bring the viewer's eye into and around the painting while creating harmony and balance. To create successful paintings, incorporate the following:

- **FOCAL POINT** This is the *center of interest*, the first place your eye goes to when you look at the painting. There are several ways to create the focal point. First, you don't want it to be perfectly centered in the picture. That will create too much symmetry and be dull. Use the *rule of thirds* to place the focal point in a more pleasing spot. Simply divide your picture plane into thirds both vertically and horizontally and place the center of interest on one of the areas where the grid crosses. You can also use other elements to direct the eye to the focal point, such as: strong contrast, complementary colors, or even lines created by other objects in the painting.
- **VALUE** Using a full range of values from dark to light will make your painting stand above the crowd. As you place your objects in the still life, consider not only their shape and size but also the value of each. How dark? How light?
- **HARMONY AND BALANCE** Repeating shapes, colors and patterns in your painting will create a sense of harmony and balance. Add a touch of drama by introducing a little variety in these areas. Strive for balance between busy space and empty space. Empty space is an important ingredient to a well-balanced composition.
- **POINT OF VIEW** From what angle will you be looking at your subject? This can dramatically change how the painting looks.

Look at page 17 to see how *Shades of Green* (page 8) would have looked from different points of view.
- **DEPTH** Create depth in your painting with value and overlapping objects. Place objects in the foreground, midground and background. Avoid placing objects right next to each other, barely touching; that does nothing for the painting's depth.

HOW COMPOSITION APPLIES

I will demonstrate these elements of composition by taking you through my process of creating *Shades of Green*, as seen on page 8. The inspiration for the painting came from my love of the green jade plate used in the still life. While at the grocery store I noticed all the green fruit that was available. They were all green, but different shades. I was intrigued by the idea of combining all these different greens, including my plate.

Working from photos of still-life setups allows you to use perishable fruit without having to hurry. Try many different ways to arrange the objects and light the setups, photographing each variation. This step can take a long time and use lots of film, but it is well worth the effort. You will be sure you have considered all of the possibilities. One idea leads to another. You may end up with a picture that you hadn't considered.

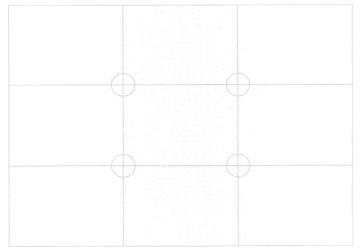

RULE OF THIRDS
The crosspoints on the grid are potential focal points for your painting.

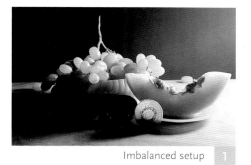

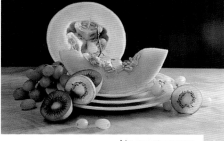

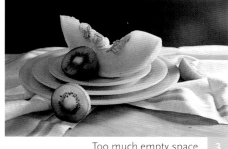

Imbalanced setup `1`

No empty space `2`

Too much empty space `3`

CREATE BALANCE AND HARMONY

In photo 1, the arrangement of the fruit is too heavy on the right. The left side looks virtually empty. Photo 2's whole composition is too busy. The three plates and honeydew melon half are just too much. Photo 3 is getting close, but it's still not quite right. The simplicity and repetition of the round shapes of the fruit and plates is nice. And the stripe effect created by the stacked plates mimics the stripes of the cloth. But the absence of the grapes with the additional green color and round shapes has left the setup a bit too sparse.

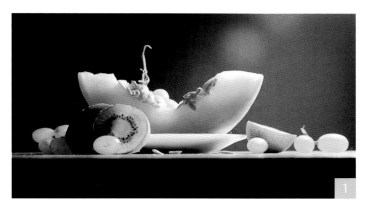

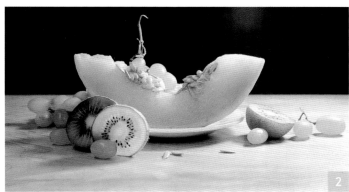

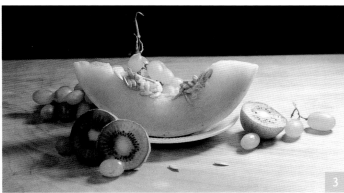

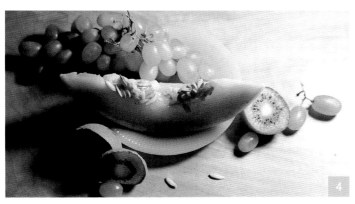

EXPERIMENT WITH POINTS OF VIEW

1 Looking up from below allows you to place the objects high in the composition giving them dominance over the rest of the picture. Lighting the objects from above or below in this perspective can create unusual shadows.

2 Looking straight at your still life creates a very intimate feeling. However, objects do tend to look flat and pictures tend to lack depth with this perspective because you don't see cast shadows across the table or other surface. Using strong lighting will help solve this problem.

3 Looking slightly down so that you see at least some of the surface on which your objects are sitting creates instant depth. The shadows cast across the surface become a part of your composition along with the objects themselves.

4 Looking from overhead has become a very popular point of view for many still-life painters. You can create interesting and unusual compositions with this perspective. Cast shadows and the texture of your surface will be very important elements in these compositions.

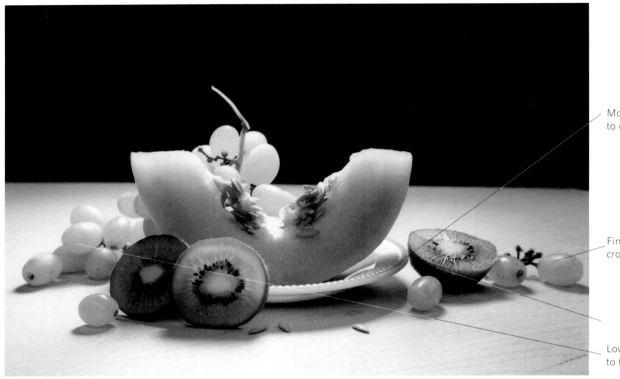

Moved kiwi to the left
to overlap the plate.

Final painting
cropped to here.

Lowered background
to this point.

THE FINAL PHOTOGRAPH FOR *SHADES OF GREEN*

This composition is almost exactly what I wanted. In the final picture I changed the placement of where the background meets the table. The placement shown here divides the picture nearly in half, which I try never to do in a painting. I lowered the background to create a better balance.

FOCAL POINT The focal point is the area around where the seeds of the melon meet the grapes. This follows the principle of thirds described on page 16. The bright light on the grapes and melon against the dark background creates value to help define the focal point as well. The overall layout has a triangular shape that leads your eye through the picture.

VALUE The use of a full value range makes this entire picture glow. The backlighted kiwi slice against the kiwi in deep shadow; the brightly lit grapes against the dark background; even the deep shadow under the lighted plate contributes to the dynamic quality of this picture.

HARMONY AND BALANCE The repetition of the circular shapes brings balance to this composition. The circular shapes are punctuated with the addition of the grape stems and the sharp points of the seeds. Color harmony is achieved with the different shades of green and also by the addition of green's complementary color in the red of the seeds and the tint of the table. I cropped the final picture to let the grapes go off the picture plane on each side. Letting some objects go out of the frame is often more interesting than showing the whole subject.

POINT OF VIEW I selected a point of view looking slightly down for this piece because it showed off the backlighting shining through the fruit better than any other perspective. The cast shadows from the objects across the table help to emphasize the lighting. The shadows also help unify all the objects and add depth.

DEPTH The multiple overlapping of objects creates most of the depth in this photo. The kiwi fruit on the right that just touches the edge of the plate is a good example of a common composition problem called *kissing*. This is when two objects just touch each other but do not overlap, creating unwanted tension. Moving the kiwi to the left a little, so that it sits behind the edge of the plate, corrects the problem.

Choose the Right Lighting

The proper lighting can set a mood and help you tell your story. Light lets the viewer know if the sun is shining or if the only light is coming from a lamp. Beyond that, light creates shadows and highlights, which contour and shape all objects. Without them, everything would look flat. Light creates a full range of values from darkest to lightest, letting you incorporate the amount of contrast you need for each painting.

Experiment with lighting and move your subjects or lights around until you get the shadows and highlights that best show off the set-up. The right lighting can add depth and drama, and can move the viewer's eyes through the painting.

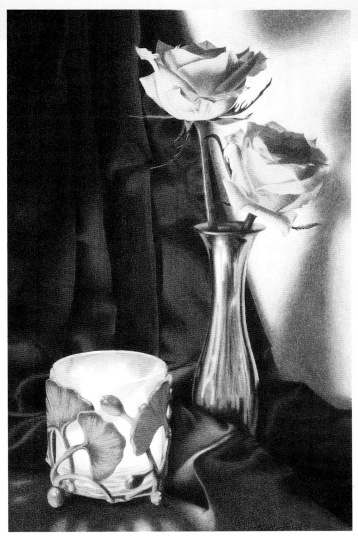

LIGHTING CREATES VALUE AND CONTRAST
The votive candle creates a wide range of values and high contrast: the bright white at the center of the candle and the deep shadows in the folds of the drape with all of the values in between. This use of the darkest darks and lightest lights creates a dramatic picture that would look entirely different without the strong lighting. The lighting also adds dramatic shadow patterns, which flare out from the votive and enhance the reflections in the vase.

Candlelight and Roses
Colored pencil on Strathmore 500 Series, regular surface
16" × 10" (41cm × 25cm)
Collection of Mr. and Mrs. Charles Barrett

Using Artificial Lighting

Still-life artists often use artificial lights for their setups. By using artificial lights, you don't have to wait for the sun to be in the right position or for the right time of day. Photographer's lights on stands are great to use; but are certainly not necessary. An adjustable light, such as a swing-arm desk lamp, enables you to direct light on the subject in different ways. I like to use trouble lights that carpenters or other workers use. They can be attached to anything, anywhere. They're adjustable and the metal inside reflects the light beautifully. Best of all, they are easily accessible and inexpensive. Use ordinary incandescent light bulbs of varying watts depending upon how much light you need. Experiment with turning off and leaving on the overhead lights; they may create secondary shadows that you don't want.

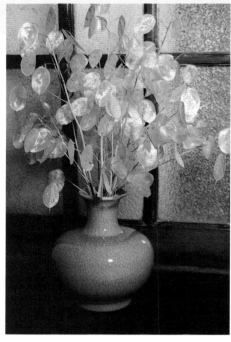

DIFFERENT LIGHTING WORKS WITH DIFFERENT SUBJECTS

I loved the money plant with the old window I found, but I had to do a lot of experimenting to find the right lighting to compliment the subjects. I began with front lighting in this picture. The subdued color palette is nice but the setup lacked depth and drama.

BACKLIGHTING COMPLIMENTS TRANSLUCENT OBJECTS

I needed to use the window more effectively to let the light source come through. So I propped the window on a table and angled it out from the wall. I fastened the trouble light to an old box and positioned it behind the window, which has semitransparent pebbled glass. After placing the vase of money plant in front of the window, I turned off the overhead lights and the result was perfect. The window's angle adds depth to the picture. The backlight shining through the translucent seed pods best showed the money plant's delicate nature. The backlighting also put the window frame and vase in deep shadows letting the vase come out of the shadow only where the light strikes the front of the bowl. This sets the nostalgic mood befitting the old time money plant.

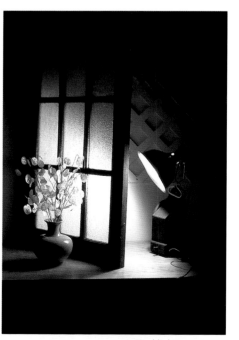

Final lighting setup

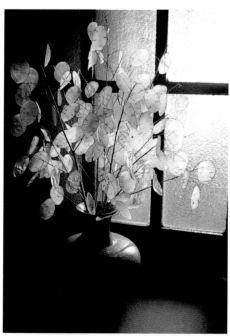

Final reference photo for *Morning Light*

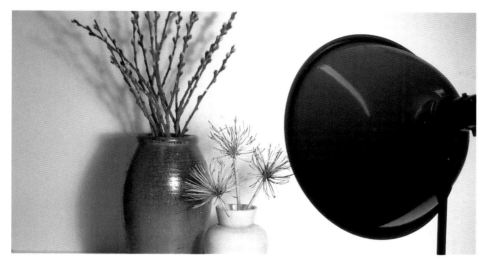

USE A SINGLE LIGHT SOURCE

You get strong, well-defined shadows, as well as highlights, with a single source of light. You could substitute the trouble light for this photographer's light and stand.

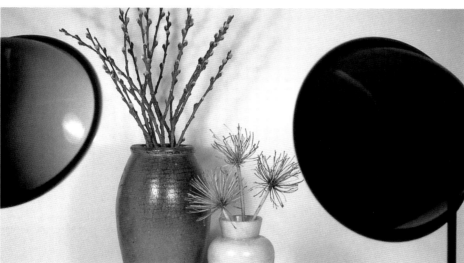

AVOID MULTIPLE LIGHT SOURCES

Two lights used for the same subject can cause confusing shadows. Shadows stretch out in both directions from each object and cause too many highlights. Although two standing lights were used for this example, an overhead light or adjacent desk light can cause the same effect.

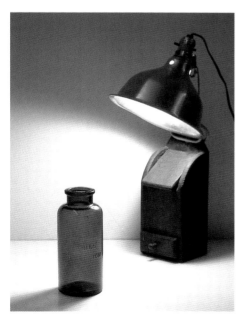

USE BACKLIGHTING EFFECTIVELY

As *Morning Light* (page 26) demonstrates, backlighting can be very beautiful. If you are going to use artificial light for backlighting, place the light off to the side or high enough behind the subject that your camera does not look directly into the light. Natural light coming through a window backlighting an object does not usually create the multiple, confusing shadows because the light is more diffused.

Using Natural Lighting

Sometimes nothing will create the lighting effect that you are after as well as Mother Nature. In this case, placing your still-life setup in front of or beside a window will work. You can also do the entire set-up outside on a deck or patio or on the floor in front of an open door. The strongest shadows are created either early in the morning in an east-facing window or late afternoon in a west-facing window. Natural sunlight adds warmth to your still-life setups with color variations that shift depending on the time of day.

Experiment with natural light the same way that you would with artificial lighting. For the painting *Bottled Twilight* (page 126), I set up the bottles in front of a west-facing window early in the morning, then took photos at different times throughout the day to capture the various lighting effects of the sun.

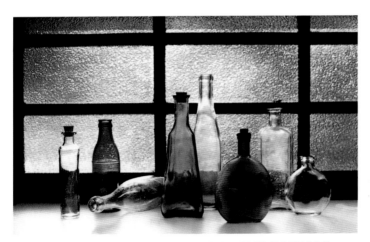

MORNING LIGHT FOR *BOTTLED TWILIGHT* (PAGE 126)
This is a photo from the morning. Because the window faces west, this morning shot doesn't allow strong direct sunlight to shine through the bottles. Stronger direct sunlight coming through the bottles would create more intense reflections on the table.

MIDDAY LIGHT
This midday photo doesn't provide much contrast. Notice the lack of reflections on the table and variation in the light of the window.

TWILIGHT PHOTO
When I took this last photo at twilight, I thought it would be too dark. But when I saw this picture, I knew immediately it was the one to use. The low position of the sun created deep, intense reflections on the table and strong contrasts. The contrasts and reflections combined with the warmth of the setting sun created an overall reflective mood. Always take lots of different pictures. You may be surprised at the one you like.

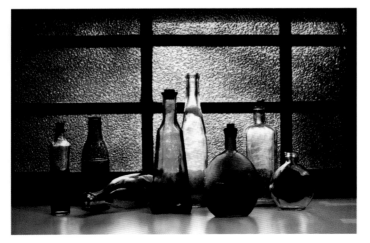

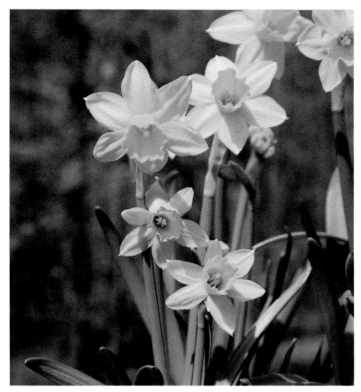

FRONT SUNLIGHT ENHANCES HIGHLIGHTS AND SHADOWS

The sun shining directly on the front of a subject, such as these daffodils, creates highlights and shadows where the petals and leaves overlap.

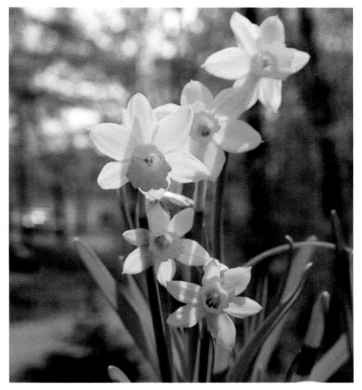

USE BACK SUNLIGHT FOR GLOWING TRANSPARENT OBJECTS

The sun shining through the back of the daffodils emphasizes the transparency of the flowers' petals. The sunlight even causes the leaves to glow.

CLOUDS DIMINISH SHINE

The beauty of the daffodils definitely suffers when they are photographed on an overcast day. The flowers lack definition and look flat, especially in the petals.

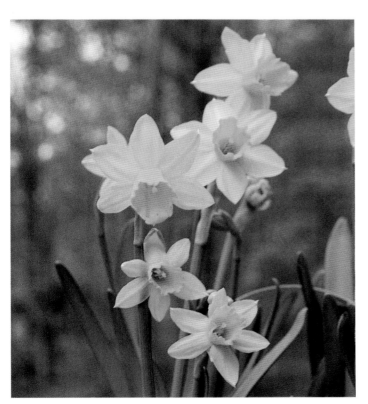

Still-Life Photographs Add Convenience

While it's useful to work on still-life paintings from life, working from photographs is more convenient. You don't have to take up space to keep the still-life set up and you don't have to worry about perishable fruit spoiling. Plus I use a lot of dark dramatic lighting which would make painting very difficult; it's just too dark. Just be aware of the distortions that photos can create, as discussed on page 34. You should also keep any non-perishable objects around so that you can refer to them if you need to.

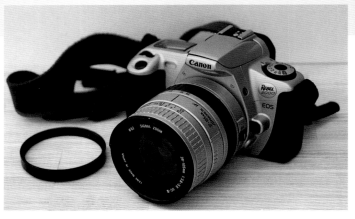

FILM CAMERA

A 35mm single lens reflex camera allows you to see exactly what your composition looks like because you are looking directly through the lens. I have a 38 to 105 lens on my Canon. You can purchase inexpensive screw-on, close-up lenses if you want shots even more close up. You can also adjust the focal length of the lens for greater depth of field. This brings everything into focus from front to back (especially important in close-ups). The camera's manual will explain most important functions.

DIGITAL CAMERA (left)

With digital cameras you can see your photos immediately and print them on your computer. Some expensive models allow you to see through the lens and make manual exposure and other adjustments. Otherwise, I still prefer the flexibility of the 35mm camera. At the very least, you want to be able to turn off the flash on your digital camera, because a flash will completely destroy your shadows.

FILM

I prefer to work from photograph prints, rather than slides, of my still-life setups. I can hold the photo in my hand and easily make enlargements with a scanner or color copier. I primarily use 800-speed film for the artificially-lighted setups in the studio. This works great for low light conditions. There's no need to worry about color correction for indoor shots. You can always adjust the color as you draw if you think it is off. If I shoot outdoors, I use 200-speed film.

TRIPOD

It is handy to have a tripod for your still-life photography. You can hand hold the camera for most setups, but, if you have a very dark set-up like *Burning Bright* on pages 72-73, you'll need to use a tripod. It takes a long exposure to photograph in low light and it is impossible to hold the camera still for all that time. You will probably get a blurry picture if you don't use a tripod.

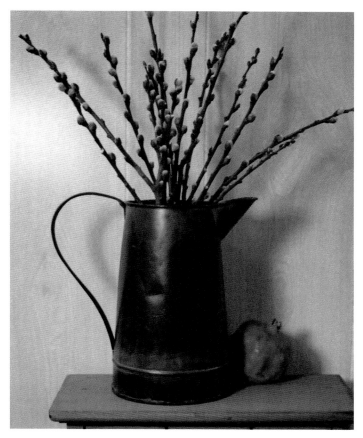

TAKE LOTS OF PHOTOGRAPHS

Don't skimp on film. Take lots and lots of photos. Try different arrangements, lighting, and angles. Take close-ups of all the objects in your still life to see the texture and detail of each item. You will be glad you have them once you begin to draw. Alter the lighting to get pictures of objects in shadows, such as the pomegranate. This enables you to see subtle detail in the shadow that you might want to show.

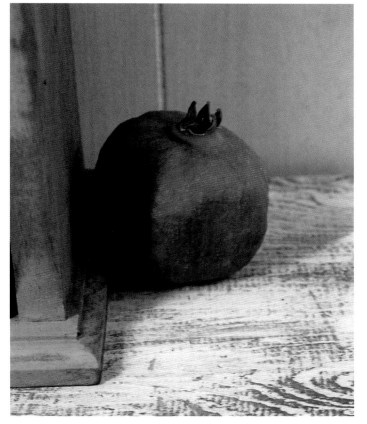

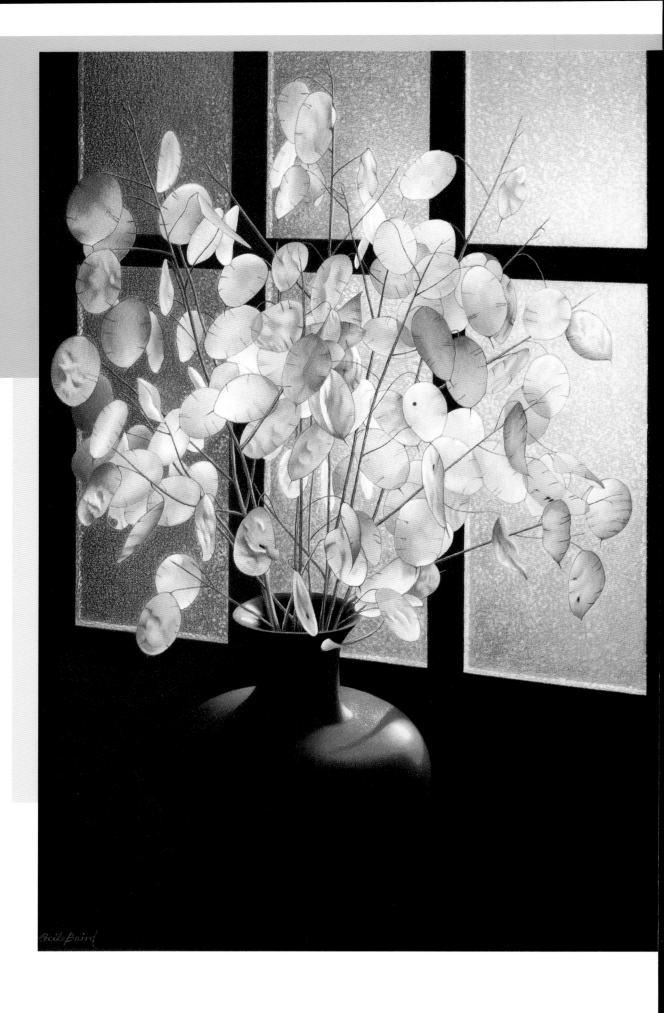

TOOLS & TECHNIQUES FOR PAINTING LIGHT

All the basics you need to create deep rich darks and glowing luminescence in your art with colored pencils is in this chapter. It only takes a few basic tools—such as paper, pencils and erasers—and some clues about how and where to use them. Using all the colors in your pencil sets, even your darkest darks, get ready to layer and burnish your way to exciting paintings that look like oil.

Morning Light
Colored pencil on Strathmore 500 Series, regular surface
20" × 14" (51cm × 36cm)
Collection of the artist

Paper

There is a large variety of paper and board available to artists today. Different surfaces accept colored pencil in different ways and affect the final look of your artwork. It is essential to know the look you want to achieve and to learn which paper will work best for you.

Paper comes in wide variety of colors as well, but to achieve the smooth painterly look, primarily use white or, on occasion, cream, tan or gray. Choose a paper that can withstand many heavy applications of color and erasing. Experiment to find what works best for you. Make sure your paper is always 100 percent acid free. After all the effort put into producing colored pencil artwork, it is important to make sure it will survive as long as possible. Use only the best archival surfaces to help ensure longevity.

MEDIUM SURFACE

Medium surface paper gives the best results for the type of colored pencil work you are doing in this book. The tooth of this paper holds lots of color, but still allows you to fill in the texture to create a smooth look. My favorite is Stonehenge by Rising. It is made from 100 percent cotton fibers, and is acid free. It has a slight tooth and will hold layer after layer of heavy color application. If you want a heavier weight, look for Strathmore Museum Board and 500 Series Bristol Board (regular surface) both come in heavier plies. Ask your local art supplier for a recommendation.

MYLAR/ACETATE FILM

Dura-Lar Matte combines the best properties of acetate and Mylar. It is matte on both sides and is semitransparent. Colored pencil goes on very smoothly. It will not hold many layers of color but you can use both sides of the film. The upper left swatch shows a single color applied to the front of the sheet. The middle swatch shows the effect to that color when a second color is applied to the back of the sheet. The bottom right shows how the same color can be deepened by applying it to the front and back of the film.

SUPPORT DRAWING PAPER

Compensate for more lightweight paper by taping it to a watercolor backing board so that it doesn't bend. Taping your paper to a separate board rather than to your drawing board offers more flexibility. You can turn your drawings easily and can put them away when you're not working.

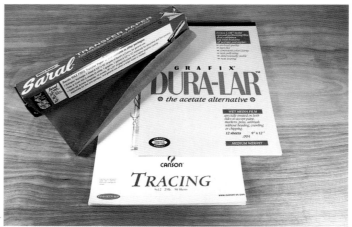

USEFUL PAPER PRODUCTS

Tracing paper, graphite transfer paper and clear acetate can all be used to create your original drawing. In order to save the surface of my fine drawing paper, I always create my drawings on tracing paper. You can change and redo the drawing as much as necessary and then transfer the drawing to your final paper.

Pencils

Manufacturers are responding to the growing popularity of the colored pencil medium by introducing new lines and colors. With the help of the Colored Pencil Society of America, a lightfastness standard has been established that offers the colored pencil artist the same standard information available in every other medium. Colored pencils suitable for the fine artist fall into three basic categories:

- **WAX-BASED PENCILS** use wax to bind the pigment. The wax in the pencil does rise to the surface and produces what is called *wax bloom*. This is not a problem and is discussed on page 38.
- **OIL-BASED PENCILS** use oil as a binder and and can be used in combination with wax pencils.
- **WATER-SOLUBLE PENCILS** contain water-soluble gum for a binder. You can use them dry or in combination with water to create a watercolor effect.

All colored pencils are semitransparent, allowing for the layering of colors with each layer showing through the one on top. But each brand of pencils has its own properties and color palette. Since I only use wax and oil pencils, I'll focus on these.

MY FAVORITE PENCILS

My favorite brand of pencils, Prismacolor by Sanford, is the most widely used and available brand. Unless otherwise noted, Prismacolor pencils were used for all the illustrations in this book. They are soft, wax-based pencils available in 120 colors. Prismacolor offers a variety of different sized sets and many art suppliers have open stock on all the colors. Begin by buying the largest set you can afford (preferably 72 or larger). The smooth rich look of burnishing (pages 37–38) requires thick layers of color made by the softer pencils. I don't use Prismacolor exclusively, though. When I need a specific color that they don't offer, I find what I need in other lines.

Variety of Brands

The major differences among the brands are: how hard the lead is, how much color it will apply, and how vivid the color looks. Softer pencils work best for the rich painterly look discussed in this book. Below is a short list of what's out there. Visit your local art supplier and experiment for yourself.

- **Bruynzeel Fulcolor** pencils have a medium-hardness and are oil-based. The pencil leads tend to splinter easily causing a lot of waste.
- **Derwent Signature Colored Pencils** are soft and wax-based. They were developed for lightfastness. The pencils go on smooth and have nice vivid colors.
- **Faber-Castell's** line, **Polychromos** colored pencils are soft and oil-based. The thick leads and casings may be too large for some pencil sharpeners.
- **Lyra Rembrant Polycolor** pencils are soft and oil-based. The line is made up of 72 colors, including a nice range of greens.
- **Sanford Prismacolor Art Stix** are short rectangular sticks that contain the same lead that's in Sanford pencils but have no casing. They are particularly good if you are going to blend with a solvent (page 39).
- **Sanford Prismacolor Verithin Pencils** are a coordinating line of hard, thin lead pencils that can be sharpened to a very fine point. They are perfect for creating tight detail work.
- **Van Gogh** pencils are soft and wax-based. The pencils lay down smooth vibrant colors that are easily blended.

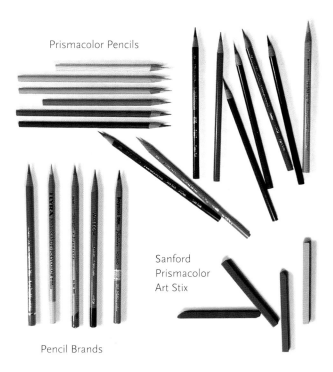

Prismacolor Pencils

Sanford Prismacolor Art Stix

Pencil Brands

Accessories

In addition to the pencils themselves there are a few other items that you'll need to take advantage of all that can be created using this medium.

PENCIL STORAGE

The boxes or tins that pencils come in do not offer the most convenient way to store, organize or carry them. Investigate pencil storage options at your local art store.

There are many commercial zippered leather or canvas carrying cases holding anywhere from 24 to 120 pencils. My homemade tote made of placemats lies very flat when open and gives easier access to the pencils than any commercial version I've seen.

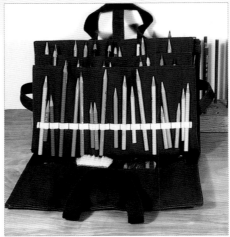

PENCIL CAROUSEL

Keep a wooden carousel beside your drawing table to organize the pencils and tools you're using on a current picture. This way, you won't have to constantly dig through pencils all over your desk or search for your eraser.

KEEP YOUR ERASERS CLEAN

Be sure to remove the color left on any eraser before you use it in a different area. You can very quickly smear the old color over your drawing instead of erasing.

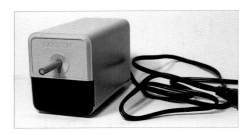

ELECTRIC PENCIL SHARPENER

Save valuable time with an electric sharpener. A simple inexpensive model will work just as well as more expensive versions. Cordless sharpeners can be nice to take to workshops, but they use so many batteries that they just aren't worth the expense for regular use.

Consider your electric pencil sharpener a replaceable accessory, like erasers. They are not made to stand up indefinitely. Prolong the life of your sharpener by cleaning it often with a brush and solvent. If colored pencil lead breaks off in the sharpener, run a regular graphite pencil through to remove the stuck lead.

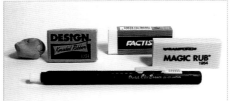

ERASERS

There is a constant need to remove color either as part of the drawing process or to keep your surface clean. Use kneaded erasers to work in small areas. These can be worked to use over and over without creating much residue. White plastic or vinyl erasers come in many shapes and sizes and can be quite rigid to very soft. All can be cut and shaped into sharp points in order to fit into tight spaces. They do create eraser residue that needs to be brushed away. Be aware though, that colored pencils stain surfaces easily and you can't always entirely remove the color.

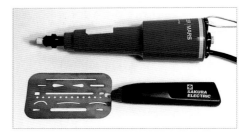

POWER ERASER

Electric or battery-powered erasers are good for large areas and erase quickly and efficiently. Handheld erasers may just push the pigment around and can create ugly smears. Small battery-operated erasers give you terrific control for going into tight places. Sharpen these with a craft knife or by laying the eraser on sandpaper at an angle while the motor is running.

Use an erasing shield with your power eraser to create a very precise edge. With a little practice you can draw lines and create detail in your color too.

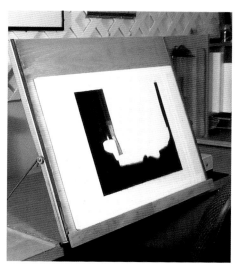

ADJUSTABLE DRAWING SURFACE

In order to see and reach all of your drawing without ruining your back, you need a drawing surface that adjusts from flat to vertical. I do most of my drawing on a nearly vertical surface and adjust the height of my chair to accommodate the height of the drawing. Commercial adjustable tables and boards are available or you can make one like this very simply.

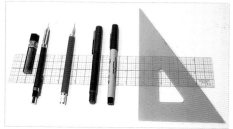

ESSENTIAL TOOLS

Rulers and straightedges, such as a triangle or a T-square, can be used to draw straight lines. A ruler in conjunction with a triangle can help you make perfect vertical or horizontal and parallel or perpendicular lines.

Mechanical pencils are convenient for when you need a graphite pencil. It's one less pencil you have to sharpen and you will always be able to make a nice thin line.

Permanent markers or technical pens can be used on acetate to make see-through grids (page 32) for creating your drawings.

A sharp craft knife can trim your paper or shave a point on the eraser. It can also be used to scratch out fine lines in your artwork (see the *Kiwi Fruit* demonstration on pages 48-50).

COLORLESS BLENDER

A colorless blender is basically a pencil with no color. It allows you to burnish or blend layers of color together without changing the hue (page 38 shows a sample of color blended with a colorless blender). There are wax-based and oil-based blenders available. Which you use is a matter of personal preference. Both can be used with all pencil brands.

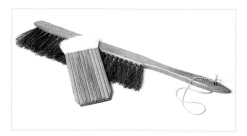

DESK BRUSH

A desk brush is essential. Colored pencils create pencil dust, especially when you use heavy pressure to burnish. So you must brush your work constantly or the colored dust will smear and ruin your work. If you make brushing as natural a part of your process as sharpening your pencils, you shouldn't have trouble keeping your work surface clean. When the end of your brush becomes stained with dust, wash it with warm water and a good brush cleaner or Murphy Oil Soap. The larger drafting brush works fine but I prefer the small hake watercolor brush (the white brush). It's convenient enough to use when traveling too.

COLOR LIFTERS

Mounting putty and a kneaded eraser can be used to lift color from your drawing. Knead and soften both, then press down and lift to remove pigment. Knead again until the color is absorbed into the putty or eraser.

Tape is also a useful tool to lift color. Masking tape works well for large areas. First, test the tape on a corner of your drawing paper to make sure it will not pull up the surface. Use transparent tape to remove very specific areas such as a single line. Place the piece of tape over the line you want to remove and draw over the line with a dull-pointed object such as a stylus or ballpoint pen. Then gently lift the tape.

SOLVENT

Solvent applied with a brush, cotton swab or pad may be used to blend colors and quickly cover a large area with color (page 39). Solvent dissolves the wax or oil and lets the color flow into the grain of the paper. Other solvents may be used, but Turpenoid turpentine has no odor. Always use adequate ventilation with any solvent.

EXTRA-STRONG GLUE AND FIXATIVE

You'll be able to glue your wax-based Prismacolor pencil stubs together to avoid wasting them. And fixative will come in handy not only to preserve your colored pencil paintings, but also to eliminate wax bloom (page 38).

Create a Line Drawing

Once you have created and photographed your perfect setup, it's time to turn that photo into a line drawing. There are several methods. No matter which method you use, do not use your good paper until you have worked out all the drawing's details. You can certainly draw your subject freehand from your photo; just know that there are other options to help speed up the process.

GRID METHOD

Place a grid over your photograph and enlarge it to the size you want your final piece to be. Then copy what is in each square of the grid. For example, you could place a ½-inch (1cm) grid over an 8" x 10" (20cm x 25cm) photo and create a 16" x 20" (41cm x 51cm) final drawing by enlarging the grid to 1-inch (3cm) squares.

PROJECTOR METHOD

Many artists like to work from slides, not only because of their color accuracy, but because of the ease with which you can project the slide directly onto your paper or board. It is best to project your image onto tracing paper rather than your final paper in case you need to do any adjusting to your drawing. You can even project photos with overhead projectors.

COPIER METHOD

Begin with an enlargement of your photo, either print an 8" x 10" (20cm x 25cm) image from a computer or get an 11" x 17" (28cm x 43cm) color copy of your photo. Then place a sheet of clear acetate or film over the enlargement and create a line drawing with a permanent marker. If you do not have clear acetate but do have a lightbox, you can create a drawing by placing a sheet of tracing paper over the enlargement on the lightbox.

You can then enlarge this drawing on a plain copier or on your computer. Since most won't be able to go as large as you want, you will need to enlarge in sections and then tape the sections together. Once you have taped the enlarged sections together you can trace the drawing onto tracing paper and make any adjustments you want. Use a proportional scale to determine what percentage enlargement you need.

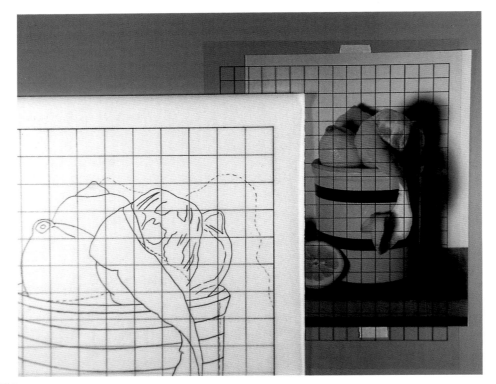

USE A GRID FOR EASY ACCURACY

Draw a variety of grids on clear acetate with either a technical pen or permanent marker and keep these on hand to use whenever you need them. You can place the clear acetate grid over the photo and see every detail. Keep some larger grids drawn on boards on hand as well. You can place these under a sheet of transparent tracing paper, then copy the drawing square by square right onto the tracing paper.

DON'T DISTORT YOUR IMAGE
Make sure your slide or photo is perfectly parallel to the drawing surface when using a projector. It is very easy to distort your image with any kind of projection.

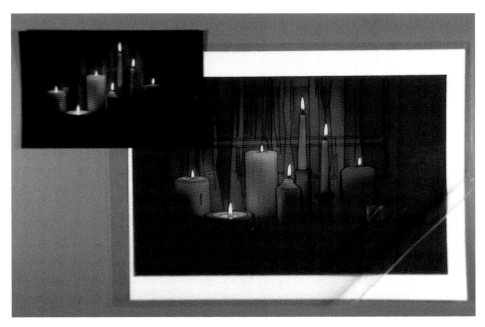

USE ACETATE FOR LOTS OF DETAIL
Since I use a lot of dark dramatic lighting in my still-life setups, I prefer to use acetate for my line drawings. It allows me to see all the detail in the dark areas.

MULTIPLE-USE TOOL
Proportional scales are inexpensive and available in many art catalogs in the drafting section. On the inner wheel, select the size of your original; then select the size of your enlargement on the outer wheel. Line the two up and the scale will tell you the percentage of the enlargement.

Drawing From Photographs

If you work from photographs you must be aware that the camera will distort objects even in a still life. Never take for granted that everything appears in your photo as it should.

Now is the time to correct any composition problems that you see. Move objects, erase and redraw until the composition is perfect. Once you've begun the actual colored pencil, it is much harder to change things around in the picture.

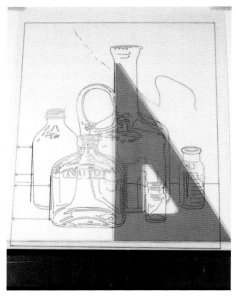 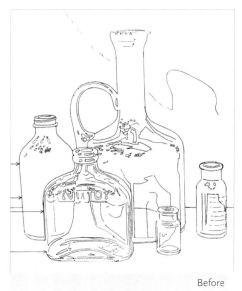 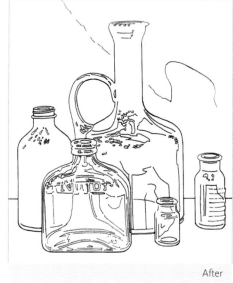

Before

After

REPAIR PERSPECTIVE PROBLEMS

In order for your finished artwork to look right, you need to straighten the sides of the bottle. Use the drafting board and triangle to draw all of the sides of the bottles perfectly parallel, which they are in reality since they all have straight sides.

The *Before* drawing taken directly from a photograph of bottles clearly shows how the camera has distorted the left sides of some of the bottles. The red arrows point out the distortion. The *After* drawing shows the corrected perspective.

REPAIR COMPOSITION PROBLEMS

This *Before* drawing was taken from a still-life setup that had good potential but I was not quite happy with the composition. I didn't like the crock sitting almost exactly in the center of the picture. This violates the Rule of Thirds for placing focal points (page 16). So, using another piece of tracing paper I moved the crock and cheese jar closer together and further to the right. The jars were too evenly spaced as well, so I moved the left jar further to the left. This created an empty space that helps bring attention on the focal point. After adding more berries to connect the items, I felt I had a much more balanced and effective composition as shown in the *After* drawing.

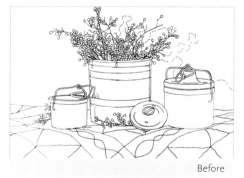 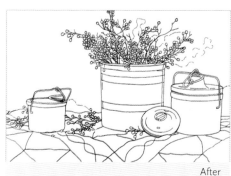

Before

After

Transfer Drawing to Your Final Paper

Now that all of the problems have been worked out on tracing paper and you have a drawing that you are completely satisfied with you are ready to transfer that drawing to your final paper.

LIGHTBOX
If you are using a lighter weight paper, you can put your drawing on a lightbox, place your paper over the drawing, and trace right onto your paper using a graphite pencil. This way you can trace your drawing as lightly as you like and are less likely to press too hard and create impressed lines. If you are using heavier paper or boards, this method will not work.

TRANSFER PAPER
Another way to transfer your drawing to paper is to place a sheet of graphite transfer paper (graphite side down) between your drawing and paper. Then trace over your drawing with a pencil or stylus; the pressure transfers the graphite. I often use a sharp Sanford Verithin colored pencil to trace over the drawing so I can see where I have been. Be careful not to press too hard. You want to avoid impressing lines into the paper as these are hard to eliminate later. Graphite paper comes in white and black.

GRAPHITE PENCIL
This is the method that I most often use. With your line drawing on the front of your tracing paper, turn it over and trace over the lines with a soft lead pencil. Then place the tracing paper drawing—front facing out—over your final paper and, using a pencil or stylus, trace over the front of your drawing. This will transfer the graphite that you drew on the back of the drawing onto your paper. Again, using a colored Verithin pencil is a good idea. You can use less pressure with this method than with the graphite paper.

How to Use Colored Pencils

As with any other medium, how you apply your colored pencils will affect the look of your finished artwork. There are as many different styles of colored pencil art as there are artists. It can be soft and airy, loose with definite strokes, or smooth and dense like a painting. Learning how sharp the pencil point should be, what kind of stroke to use, and how much pressure is needed to create the look you want are the first skills that any colored pencil artist should master.

BEGIN WITH SHARP PENCILS AND EVEN STROKES

Sharpen your pencils often. If you try to apply colored pencil with a dull point, the color will sit on top the texture of the paper and leave a lot of white showing through the color. Using a very sharp point allows you to go down into the valleys of the paper and gives you more coverage.

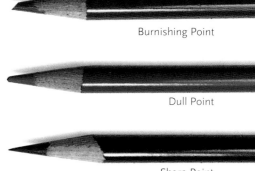

Burnishing Point

Dull Point

Sharp Point

CIRCULAR STROKE

Use this stroke to create a nice even area of color. Keep a very sharp point and overlap the small circular strokes. Be careful not to go in a definite pattern or line. No strokes should be visible when you have finished.

LINEAR STROKE

Apply all these strokes in the same direction and overlap to fill in an area of color. The only drawback to this stroke is that you often get darker areas of color where the strokes overlap.

PENCIL POINTS

One point doesn't serve all purposes. You'll have occasion to use three different pencil points while working with this book.

BURNISHING POINT is a blunt point that you'll use mainly with heavy pressure to blend layers of color.

DULL POINTS create textures such as linen where you want the white of the paper to show through. The dull point stays on top of the paper and doesn't go into the valleys.

SHARP POINTS are used to apply layers of colors. You can go down into the valleys of the paper with this point to get more coverage.

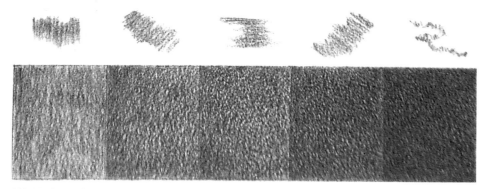

MULTIDIRECTIONAL STROKE

I find it most comfortable to apply color with small linear strokes, but run into the overlap problem. To avoid these dark areas, I have adopted a multidirectional stroke. Again, keep a sharp point and fill in the area with short, vertical strokes. Next, fill in the same area with a diagonal stroke, then horizontal, then the opposite diagonal. Turning your work will make it easier to apply the different strokes. Finally, go back in with a sharp point and fill in empty areas with a small multidirectional stroke. The different directions cover up any overlapping and give a nice even area of coverage. You don't always have to go in every direction. Just do as much as you need to get the coverage you want.

CONTROL PENCIL PRESSURE

It may take a while to learn to control the amount of pressure you use when using colored pencils. This is especially true for light pressure. Hold the sharp pencil as you normally would but let it float in and out of the texture of the paper. The other extreme is pressing down very hard with a blunt point until the color blends together and actually presses down the texture of the paper.

WHY IS PRESSURE IMPORTANT?

One of the most beautiful and exciting aspects of colored pencils is that they are semitransparent and color upon color can be layered to create stunning and vibrant works of art. You can see down through each layer into the next color. But because colored pencils are wax or oil based, you can saturate the paper with so much pencil that no more color can be applied. Make sure you've added all the color you need before you reach this saturation point. Applying color with light pressure will allow you to use many more layers than would be possible with heavy pressure.

WHAT IS BURNISHING?

Burnishing is the step that gives colored pencil the smooth look of an oil painting. It means applying heavy pressure to blend layers of color from wax or oil-based pencils to completely cover the paper grain, allowing no paper to show through and resulting in a smooth, shiny area of color.

To burnish you first build up several layers of color. Then, using heavy pressure and a blunt burnishing point, you blend all the layers together. This mingles all the colors and makes your work vibrant.

In order to make sure your burnished color is as rich as possible, it's important that your layers of color are nice and dense. If your layer of color is too thin, you will not have enough color to blend together and it may be hard to cover the paper. (See *Dense Color With Light Pressure* below.) Also remember that because you are using heavy pressure to burnish, it's important to use a blunt point. Heavy pressure on a sharp point will indent your paper.

There are several different types of pencils you can use for burnishing. Each will give you a slightly different look. Prismacolor and Lyra both make colorless blenders, which are pencils without pigment added. You can burnish and blend colors with these blenders without adding any additional color.

Burnishing with a white or any light colored pencil blends the colors beautifully, but it does lighten them. In all burnishing it is possible to apply color, burnish, reapply color, and burnish again until you reach your desired color or reach the saturation point. How many times you can reapply color depends on how much color and pressure you use and will vary slightly with each case. It is also possible to burnish with additional color, as indicated in *Burnish With Color* on the next page where Indigo Blue, Tuscan Red and Crimson Lake were burnished with Scarlet Lake.

PRESSURE RANGE

It is important not to apply too much heavy pressure too soon. Note how saturated the heavy pressure example appears. If you reach this saturation point too early, you will limit the amount of color you can apply.

Light

Heavy

DENSE COLOR WITH LIGHT PRESSURE

Since it's important not to use heavy pressure too soon, apply your colors with a light touch. You can apply thin or dense layers of color with the same light pressure. To get the dense layers you need for burnishing, apply a thin layer of color using a very sharp point and light pressure and then go over the area again with the same light pressure. Use the multidirectional stroke to go over the area as many times as needed until you reach the desired density.

Thin

Dense

BURNISH WITH COLORLESS BLENDER

Colorless blenders are pencils without pigment. You can burnish with these blenders without adding additional color.

In this example I began with Poppy Red layered with the multidirectional stroke and light pressure. In the same manner, I layered Sunburst Yellow, letting it overlap into the Poppy Red. Notice the dense color in each square. I then used a colorless blender and blunt burnishing point to burnish the colors. Notice how burnishing makes the white of the paper disappear and brings out the intensity of the red and yellow. How do you think the colorless blender compares with the examples burnished with white and with color?

Poppy Red

Poppy Red +
Sunburst Yellow

Poppy Red +
Sunburst Yellow
burnished with
colorless blender

BURNISH WITH WHITE

Burnishing with white tends to lighten the color, but you can reapply color to bring it back. You can always apply color, burnish, reapply color and burninsh again until you reach the desired color or the paper's saturation point.

In this example I began with True Blue. Then burnished the blue with white. Notice how the grain of the paper is completely filled but the blue is much lighter. That's when reapplying the original color or colors will bring back the intensity.

True Blue

Burnished with
White

Burnished with
White, True Blue
added

BURNISH WITH COLOR

Using color to burnish almost always gives the most intense results. In this example I began with densely applied Indigo Blue faded out into the right. Then I applied a dense layer of Tuscan Red over the blue and faded into the right. I burnished these with Scarlet Lake, covering the entire square. Isn't the dark side rich and the red brilliant?

Indigo Blue

Tuscan Red

Crimson Lake
Burnished with
Scarlet Lake

WAX BLOOM

One result of burnishing with wax-based pencils is an occurrence called *wax bloom*. After an area has been burnished for a while, the wax migrates to the surface and forms a grayish film. It is particularly noticeable in dark areas. You can easily correct this by buffing the area with a soft cloth or tissue and spraying it with a fixative. This will permanently remove the wax bloom and keep the pencil from smudging. I use the UV-Resistant Fixative by Krylon. It not only fixes the wax bloom but also gives a nice overall sheen to the picture. I wait until the entire picture is done before using the fixative. Oil-based pencils do not create wax bloom.

Get Great, Fast Results With Solvents

Colored pencil is, by any definition, a slow medium to use. As it has grown in popularity, however, artists have discovered ways to speed up the process. Filling large areas with color quickly can really cut down the time spent on a piece. Because pencils are wax or oil based, solvents can be used to dissolve and spread the color. I recommend Turpenoid in the blue can because it doesn't produce noxious fumes. Take the same precautions with Turpenoid that you would take with any solvent and ask your local art supplier for recommendations.

Using solvent is simple. Just apply your colored pencil; don't be too careful about the strokes, but do put down enough color. I prefer to use a flat brush to apply the solvent, but you can also use cotton swabs or pads. A short flat brush called a bright gives more control, especially at the edges, than the longer flat brushes called flats.

The only trick with solvent is to figure out how much to use. It takes very, very little. Pour a small amount into a lid or dish, then add more as needed.

You can apply several layers of color and solvent over each other, but be sure to let the solvent dry thoroughly before going over it with more color. I usually finish an area that is blended with solvent with a layer of straight colored pencil to cover up any imperfections.

In addition to applying color over solvent areas, you can create effects over them by removing color. You can scratch out lines with a sharp craft knife, or create soft shading with a kneaded eraser. You can even draw on the solvent areas with an electric eraser.

PRACTICE USING SOLVENTS

First apply Peacock Green, then apply Indigo Blue and Violet. Dip your brush into the solvent and wipe most of it off with a paper towel. Using circular strokes, go over the entire area blending the color together and covering the paper completely. Add Indigo Blue and Chartreuse, and then reapply solvent. This is a fast and easy way to cover large areas, such as backgrounds.

Peacock Green

Indigo Blue + Violet

Apply Solvent

Indigo Blue + Chartreuse, then reapply solvent

SOLVENT TRICKS FOR YOUR COLORED PENCIL TOOLBOX

Once you've learned to successfully apply solvent, try these techniques in your paintings.

Add colored pencil over

Scratch out lines with craft kniffe

Softly erase with kneaded eraser

Draw with electric eraser

BE CAREFUL!

Practice the solvent technique before trying it on a final piece. If you use too much solvent in your brush, you will not blend the color but will actually remove it.

Use Value Generously

Value is the range of tones in a picture from lightest to darkest. It is one of the most important principles in art. Learning to see and understand value is essential for any artist. You will constantly need to compare the value of one object or area against another.

One of the most common mistakes artists make, especially beginners, is to use only middle values in their work. They seem to be most afraid of using really dark darks. *Contrast* is the difference between values. Using only middle values will make your work lack contrast and look flat and uninteresting. Adding darks and lights will increase the contrast and add depth and interest. Value and contrast can help highlight your center of interest, lead your eye around the painting and convey a mood to the viewer.

HOW TO SEE VALUE

The first step is to learn to see values. Sometimes color makes determining value difficult. Eliminating color helps make the values stand out. One way to do this is to place a red sheet of acetate or vinyl over your color reference photo. The values will be much more prominent when the color is neutralized.

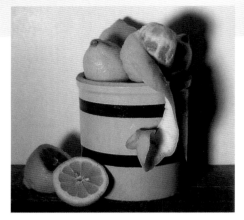

COLOR SOMETIMES DISTRACTS FROM VALUE
The color differences in a setup can make it difficult to focus on the value differences.

NEUTRALIZE COLOR TO SEE VALUE
A see-through red report cover was used in the sample above. The red neutralizes the color and makes the picture monochromatic, which makes values more recognizable.

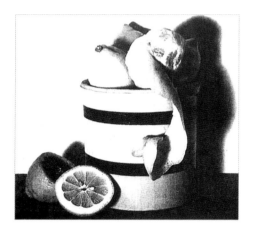

ELIMINATE COLOR TO SEE VALUE
Another good way to isolate values is to turn your reference into a black-and-white image. This can be done on a copier (use a photo setting if it has one) or scan and print a black-and-white version on your computer. With no color you can easily tell where the darkest and lightest values are. You can easily see the contour shading of the crock—especially around the bottom—and the lemons.

MAKE A VALUE SCALE
Drawing a value scale for yourself will be good practice and a useful reference tool. A value scale is simply a set of squares each containing a value from the lightest to the the darkest. This sample contains seven different values between white and black. Place this scale beside the different parts of your black-and-white reference to determine the value of each area.

MAKE A COLOR VALUE SCALE
Single colors have a limited value range, as shown in this Terra Cotta value scale. Even when applied full value as on the far right, the Terra Cotta cannot become any darker. To get a darker value, you would have to add another color, as with the Indigo Blue in the *Burnishing With Color* example on page 38.

Discover Color

Learning to see all of the colors in your subject is another crucial step in creating exciting and dynamic art. Light changes the color of objects as it passes over or through them. Objects side by side affect the color of each other. An object receding into the background will be a different color than the same object in the foreground. The darkest shadows have color in them if you look closely, and white objects can contain an amazing amount of color.

Look at your subjects abstractly. Forget what your subjects are and look very closely to determine what colors you see. What color is in the highlight? Can you see yellow and blue in a red grape? Is the shadow on a white object really gray or does it contain lavender and blue? Learn to go with what you see. Soon you'll be seeing color you've never noticed before. Put that color in your paintings and you will achieve the look that you've admired in others' work.

The examples on this page and the next show how I analyze the colors in a subject and then translate that into colored pencil artwork.

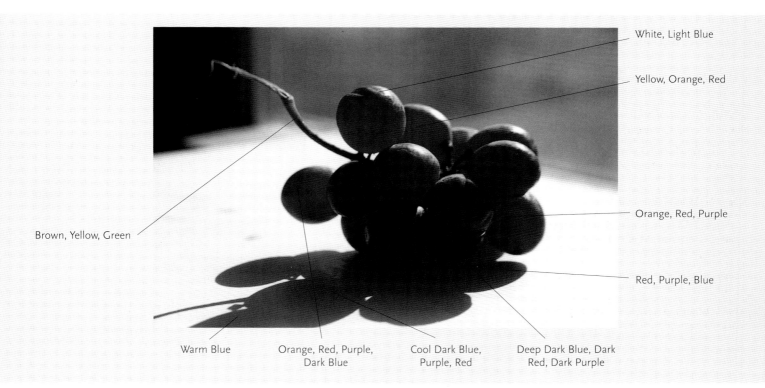

White, Light Blue

Yellow, Orange, Red

Orange, Red, Purple

Red, Purple, Blue

Brown, Yellow, Green

Warm Blue

Orange, Red, Purple, Dark Blue

Cool Dark Blue, Purple, Red

Deep Dark Blue, Dark Red, Dark Purple

ANALYZE THE COLORS IN YOUR REFERENCE PHOTO
What other colors do you see?

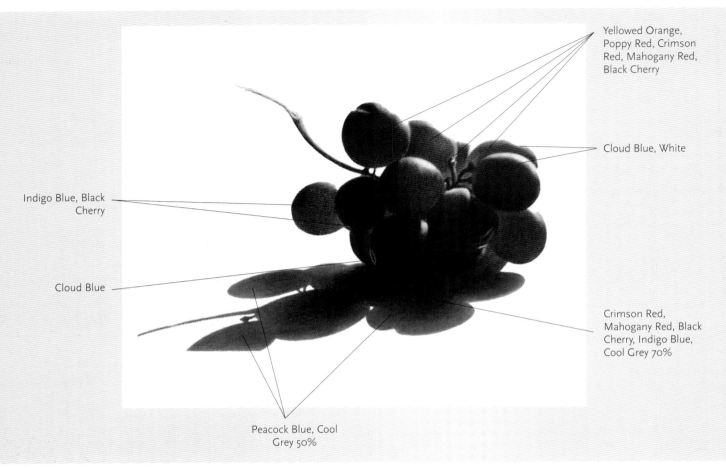

Yellowed Orange, Poppy Red, Crimson Red, Mahogany Red, Black Cherry

Cloud Blue, White

Indigo Blue, Black Cherry

Crimson Red, Mahogany Red, Black Cherry, Indigo Blue, Cool Grey 70%

Cloud Blue

Peacock Blue, Cool Grey 50%

CREATE THE COLORS YOU SEE IN COLORED PENCIL
Match the colors you see in your reference with the colors in your pencil palette.

COLORS YOU'LL ALWAYS NEED

Once you've done several pieces of colored pencil artwork, you will find that you use some colors over and over in almost every piece. Prismacolor offers three different shades of gray (Cool Grey, Warm Grey and French Grey) in percentages from 10% to 90% in each shade. You will make great use of these. Other colors I use consistently include:

Black Grape · Celadon Green · Cream · Dahlia Purple · Dark Umber · Greyed Lavender · Indigo Blue · Limepeel · Peacock Green · Rosy Beige · Terra Cotta · Tuscan Red · Yellow Ochre

Colored pencils are semitransparent. Layering colors will allow you to liven up colors or create new ones. Any layered color looks more vibrant and interesting than a single color. The combination of layering and burnishing creates incredibly rich and luminescent art. That's what excited me about colored pencil. The layers will work together to create exciting color whether or not you burnish them. These layering examples show that even your darks can be colorful and rich. The combinations are endless! All of the samples were done with Prismacolor pencils.

LAYER COMPLEMENTS FOR BEAUTIFUL BLACKS

The question my students often ask first is how to achieve the rich darks they see in my paintings. They cannot believe such richness and depth is possible with colored pencil. It's easy with layered colors and burnishing. Try this yourself, then compare this black with a straight black pencil. You will be amazed at how much richer the layered black looks.

Tuscan Red Peacock Green Indigo Blue Burnish with Colorless Blender

LAYER COMPLEMENTS FOR COLORFUL NEUTRALS

Combined complements always make neutrals. Since colored pencils are semitransparent, each color—here Periwinkle and Orange—shines through in the final, burnished layer. This is how you create luminosity.

Periwinkle Orange Periwinkle Burnish with White. Apply Periwinkle over White on right half to produce a cooler gray.

LAYER COLORS NEXT TO EACH OTHER ON THE COLOR WHEEL

Each layer of color adds richness and depth. Even layering colors next to each other on the color wheel, as seen in this example, adds depth. When burnished together, each layer shines through.

BURNISHED WITH COLORLESS BLENDER

Spanish Orange + Orange + Poppy Red Spanish Orange + Orange Spanish Orange Spanish Orange + Spring Green Spanish Orange + Spring Green + Grass Green

BURNISH FOR LUMINOSITY

These colors are layered in the top row and then burnished with a colorless blender in the bottom row. Can you see how much brighter and richer the colors are?

BOTTOM HALF BURNISHED WITH COLORLESS BLENDER

Process Red + Limepeel Process Red + Sunburst Yellow Process Red Process Red + Violet Blue Process Red + True Blue

Layer Complementary Colors

Complementary colors are colors opposite each other on the color wheel. The complement of red is green, of blue is orange, of yellow is purple. Complementary colors vibrate and enhance each other when used together. As shown in the layered black and layered gray samples on the previous page, when you mix complements you create interesting neutrals. Using the complements in your drawing to create neutrals will create more exciting color and help unify the whole picture.

But complements can do much more than create gray and black. Following are several examples of how to use complementary colors to enhance your work.

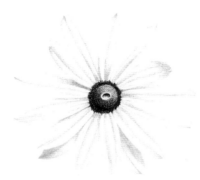

CONTOUR WITH DARK PURPLES
Contour the petals with Greyed Lavender and the center with Black Grape.

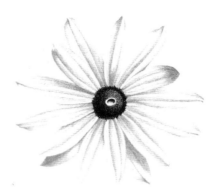

LAYER FOR NEUTRALS
Add Goldenrod over the Greyed Lavender and Dark Brown over the Black Grape.

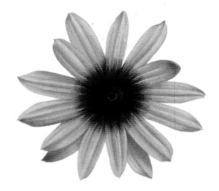

FINISH DETAILS AND SHADOWS
Finish the Gloriosa Daisy with Sunburst Yellow, Canary Yellow and White on the petals. Deepen the shadows on the petals with more Goldenrod. Add the red around the center with Crimson Red and Crimson Lake. Cover the center with Terra Cotta and then deepen the shading with Black Grape, Indigo Blue, Dark Brown and even a little Black in the darkest areas.

CONTOUR WITH BLUE
Contour the shape of the orange with Blue Violet Lake in the darkest areas, Blue Slate in the middle areas and Cloud Blue in the lightest areas.

ADD THE COMPLEMENT
Color the orange with Spanish Orange, Yellowed Orange, Orange, Pale Vermilion and Carmine Red.

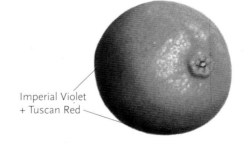

Imperial Violet + Tuscan Red

DARKEN THE SHADOWS
You can deepen the shading even further by adding Imperial Violet with Tuscan Red over that.

Place Complements Side by Side

You've learned how to shade and contour using complementary colors to make your art glow. You can also apply this principle in your paintings by choosing objects for your paintings based on their complementary qualities. When placed next to each other, objects with complementary colors, such as the green cup and the cherry, enhance one another. Each makes the other seem brighter and more colorful. You can use this trick to add spark to any painting.

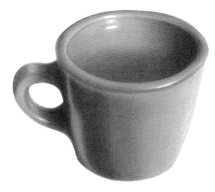

CONTOUR THE CUP WITH GREEN
Begin with this simple green cup whose contours were shaped with red under the green.

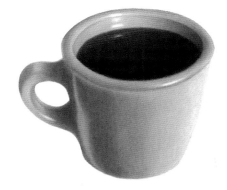

ADD RED COFFEE
Add some reddish coffee to the cup. The green cup really makes the coffee sparkle.

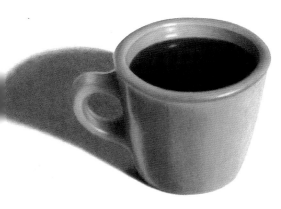

PLACE A COMPLEMENTARY SHADOW
Add a complementary cast shadow to make both the object and its shadow complete each other.

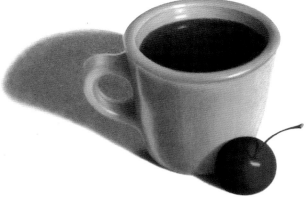

BRIGHTEN THE PAINTING WITH ADDITIONAL COMPLEMENTS
The addition of another complement, the bright red cherry livens this simple little setup.

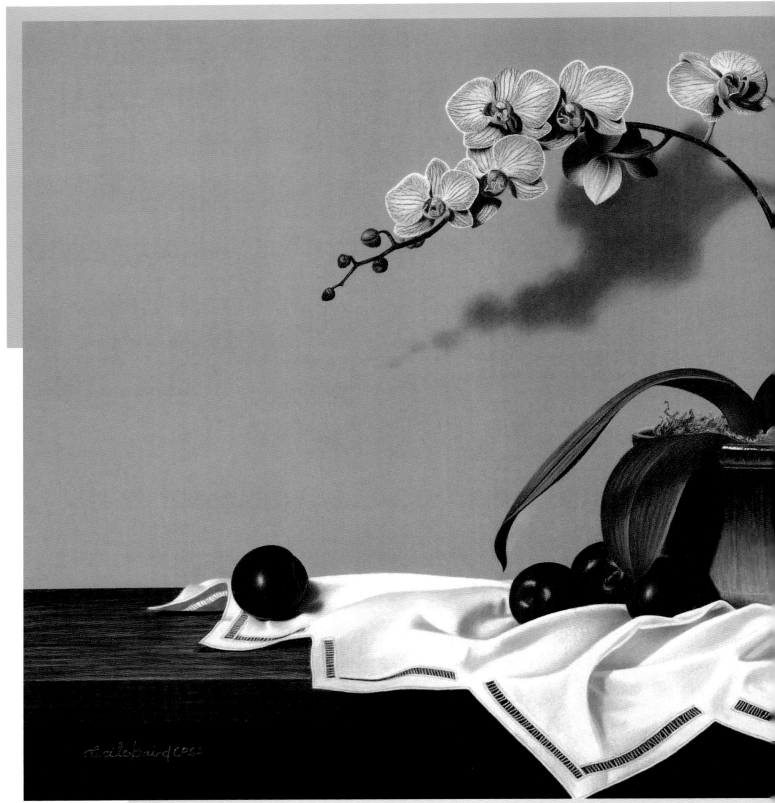

Plums and Orchids
Colored pencil on white Stonehenge paper
11" × 14" (28cm ×36cm)
Collection of the artist

CREATE FRUIT & FLOWERS THAT GLOW

Fruit and flowers are essential components of many wonderful still-life paintings. Their beauty and variety is limitless. Add light to them and your paintings will jump off the page. To see for yourself, shine light through a slice of kiwi fruit or a bunch of grapes. Can anything be more beautiful than the sun shining through the petals of a rose or an autumn leaf? Light bouncing off of an apple can add depth and sparkle to any painting.

The techniques and step-by-step demonstrations in this chapter will teach you to make your still lifes radiant. Viewers of your art will not believe your paintings are done with colored pencil.

STEP-BY-STEP demonstration
kiwi fruit

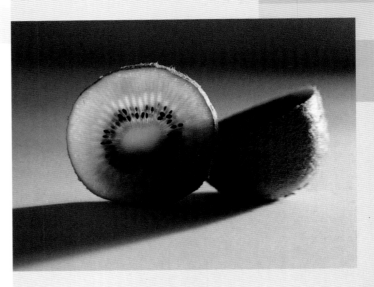

I used this backlit kiwi in one of my favorite paintings, *Shades of Green* (page 8). Putting in the background and cast shadow help emphasize the backlighting. The lighting not only shows off the design of the interior of the fruit but also highlights the fuzzy skin. Follow the step-by-step demonstration to learn first hand how lighting can turn an ordinary subject into a piece of art.

materials

Derwent Artists Pencils

Golden Brown

Prismacolor Pencils

Apple Green · Black · Black Cherry · Bronze · Burnt Ochre · Clay Rose · Cream · Dark Green · Dark Umber · French Grey (10%, 20%, 30% and 50%) · Goldenrod · Grass Green · Indigo Blue · Limepeel · Olive Green · Peacock Green · Sand · Terra Cotta · Tuscan Red · Warm Grey (10%, 20%, 30%, 50%, 70% and 90%) · White · Yellow Ochre

Verithin Pencils

Light Grey · Sienna Brown

Other

Colorless blender · Craft knife · Kneaded eraser · White Stonehenge paper

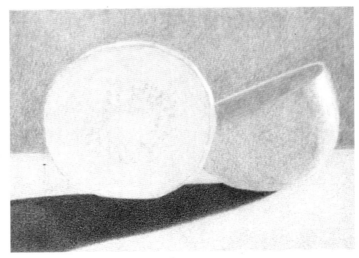

1 Lay In the Foundation Colors

Tap a kneaded eraser lightly over the lines to lighten your pencil drawing. Lightly outline the seeds with Verithin Light Grey and the fruit edge with Verithin Sienna Brown. With a sharp point, use light pressure and the multidirectional stroke for these dense foundation layers.

Use Cream for the the kiwi slice and Limepeel for the top of the kiwi half. Fill in the skin side of the half with Derwent Golden Brown using a circular stroke to mimic the nubby skin of the fruit. Cover the highlight areas of the skin side with Cream except for the very white area.

Begin with a layer of Black Cherry for the cast shadow. Add Indigo Blue over all but the left lighter edge of the shadow. The shadow has a crisp edge in the back and a soft diffused edge in front. Use Warm Grey 10% for the table and Clay Rose for the background.

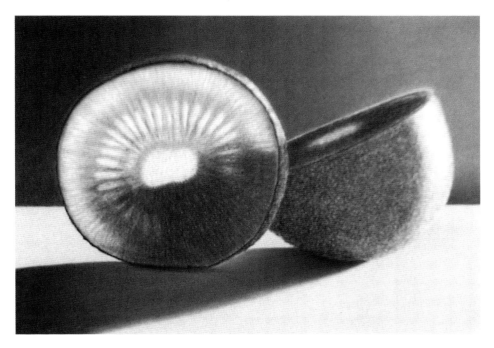

Finish the Background and Begin to Develop the Kiwi

Because eventually you'll create the rough, fuzzy skin of the kiwi by scraping it out of the background and shadows, you need to complete the shadow and background before moving on to the kiwi fruit.

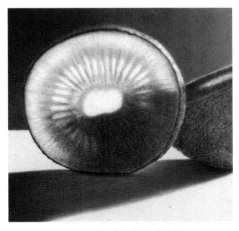

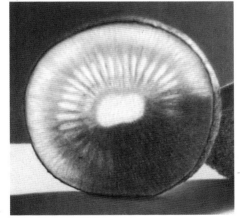

BURNISH THE SHADOW AND BACKGROUND

With a blunt point and heavy pressure burnish the shadow using all the French Greys. Blend one shade into the next with the darkest under the fruit. Add Apple Green under the slice and Terra Cotta under the half. Burnish the background with Warm Grey 20%, 30% and 50% with the darkest on the left and lightest on the right. Burnish the table with Warm Grey 10%.

BEGIN THE KIWI SLICE

Use a sharp Clay Rose pencil and light pressure to form the center ring. Cover with Goldenrod and form the shapes over the rest of the light portion. Cover that with a fairly dense layer of Limepeel. Layer Tuscan Red lightly, then Olive Green densely over the dark area. Finish the inside with a very light layer of Peacock Green over the Olive Green. Outline the slice with Dark Umber.

BEGIN THE KIWI HALF

Lightly layer the inside with Clay Rose and Tuscan Red. Apply a dense layer of Olive Green and a little Peacock Green. Add some Olive Green on the skin except for the highlight area. With a circular stroke, apply Golden Brown around and blend it into the highlight area. Add Burnt Ochre then Terra Cotta the same way over the side of the fruit, blending into the highlight. Apply Dark Umber on the darkest part of the skin shadow. Fill the dots on the skin with Olive Green.

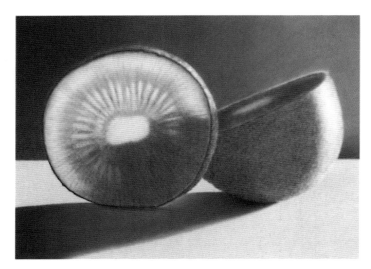

3 Burnish the Kiwi Fruit

Burnish the lighter part of the slice with Limepeel, then Cream. Use Yellow Ochre to burnish the darker part of the slice and the inside of the half. Use a blunt point, heavy pressure and multidirectional stroke on these. Then burnish the skin of the half with a colorless blender using a circular stroke and medium pressure. You want to have a textured look to the skin.

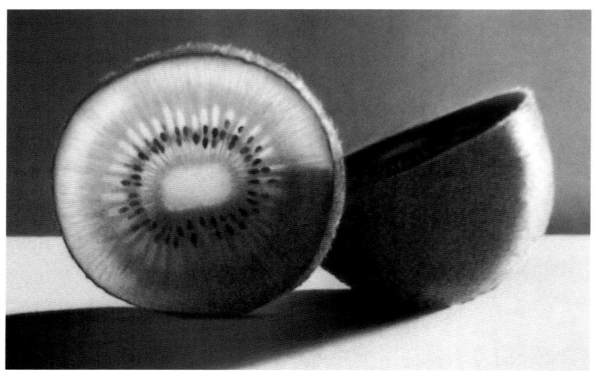

4 Bring the Kiwi to Life

With a sharp point and medium pressure, apply Clay Rose and Bronze over the center ring of the kiwi slice. Darken with some Bronze burnished with Cream to the slice. Apply Apple Green and Grass Green over the areas where the Goldenrod was in previous steps. Cover the darker area with light layers of Tuscan Red, Peacock Green, Indigo Blue and Peacock Green again. Define the seeds with a very sharp Black. Add Apple Green underneath to finish.

Kiwi Half On the inside apply Tuscan Red then Peacock Green over all but the center. Cover that with Olive Green and Burnt Ochre. Add the seeds with Black and pick out the lighter pattern with strokes of Sand. Complete the skin with circular strokes first of Indigo Blue in the darkest shadows, then Terra Cotta and Dark Umber over the rest of the shadow. Work Burnt Ochre and Golden Brown from the right highlight into shadow. Put some Black over the deepest shadow and fill in holes with Dark Green.

Scratch out the fine hairs of the skin that the backlighting highlights with a sharp, new craft blade. Touch them with Burnt Ochre. Touch the highlight on the side with White. Darken the shadow with Black and 90%, 70% and 50% Warm Grey. Add Dark Umber underneath to finish.

STEP-BY-STEP demonstration
cantaloupe

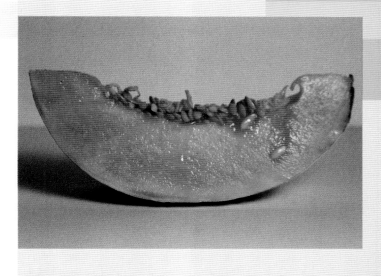

When I first set out to do a slice of melon, I wanted to use backlighting. But when I saw the light hit the juice dripping off of the freshly cut cantaloupe, I knew I'd found the right lighting. This demonstration will show you how to capture that juiciness, the texture created by the light and the juice on the side of the slice, as well as all the subtle color variations within the cantaloupe's mostly monochromatic (single) color. Doesn't the touch of green in the rind make the entire picture?

materials

Bruynzeel Pencils

Indian Yellow · Light Ochre

Prismacolor Pencils

Beige · Bronze · Cool Grey (10%, 30%, 50%, 70% and 90%) · Cream · Dark Umber · Deco Orange · Goldenrod · Grass Green · Indigo Blue · Limepeel · Marine Green · Orange · Pale Vermilion · Poppy Red · Sand · Scarlet Lake · Slate Grey · Tuscan Red · White · Yellow Ochre · Yellowed Orange

Verithin Pencils

Tuscan Red · Indigo Blue

Other

Colorless blender · Craft knife · Natural Stonehenge paper

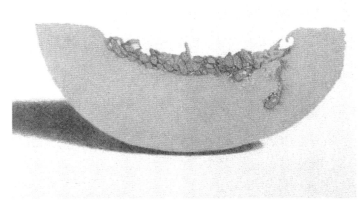

1 Lay Down the Base Color and Define the Seeds

Using a very sharp Bruynzeel Light Ochre pencil and light pressure, outline and fill in around the seeds. Fill in the seeds with Goldenrod, leaving the white highlights. Leaving only the white highlights, fill in the rest of the melon with a light layer of Beige, covering the rind area at the bottom and the remaining pulp area at the top. Use a sharp pencil, light pressure and multidirectional stroke. Apply a light layer of Slate Grey to begin the shadow. Soften the outer edges of the shadow, but keep the edges crisp under the melon.

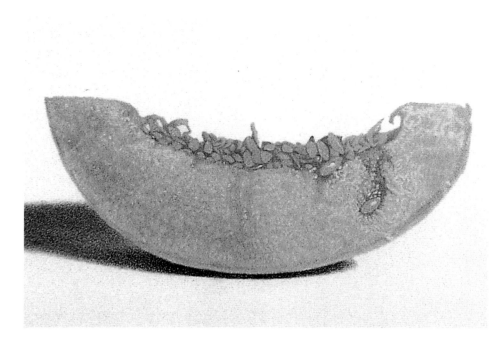

2 Define the Texture

Begin with Deco Orange and a hit-and-skip circular stroke on the side of the cantaloupe. Use a sharp point to go around highlights, then let your point go a little dull. Hit and skip back and forth, playing with the grain of the paper. Define the darker areas on the side of the melon first, then work around them. Apply a light layer of Sand over the Deco Orange. Define the rind with a wide strip of Sand and a narrower strip of Limepeel in the middle of that.

Outline the seeds with a light layer of Deco Orange and Bruynzeel Light Ochre, extending this color down into the drip areas. Fill in the seeds with Sand. Apply a light layer of Bruynzeel Indian Yellow over the dark areas on the side.

Apply a light layer of Tuscan Red directly under the melon where you see the darkest shadow. Cover this with a light layer of Indigo Blue letting it extend beyond the Tuscan Red and fading out on the left-hand side of the shadow. Apply the shadow colors with a sharp point, light pressure and the multidirectional stroke.

3 Burnish With a Colorless Blender

Burnish the entire melon and shadow, except for the white highlights, with a colorless blender. Apply heavy pressure using a blunt burnishing point and the multidirectional stroke. Because light colors have been used, you may not see a great change after the burnishing, but you have filled in the grain of the paper and blended the colors together.

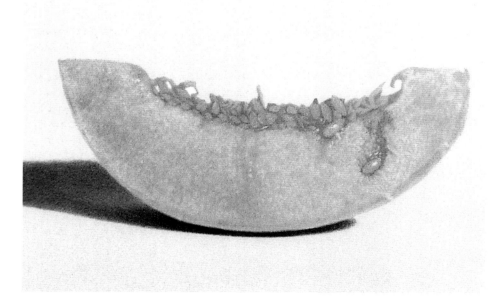

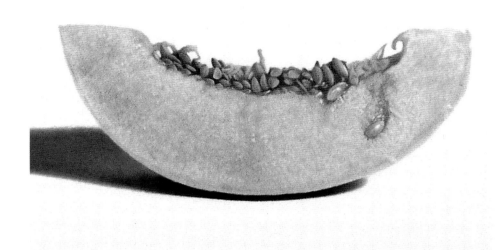

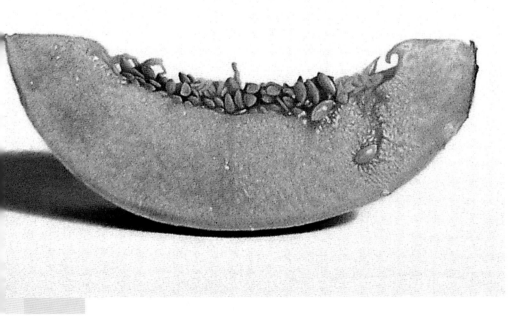

4 Finish the Seeds and Shadow

Fill in the seeds with Goldenrod and heavy pressure, leaving the white highlights. Contour with Cool Grey 30% on the lighter seeds and Cool Grey 50% on the darker seeds. Add a little Pale Vermilion and Orange to bring in the color of the pulp. Burnish the seeds with Cream and Sand. Hit the highlights with White now.

Reapply Bruynzeel Light Ochre with heavy pressure to the pulp around the seeds. Make the dark areas with Cool Grey 30%, 50% and 70%, then Scarlet Lake and Poppy Red. Cover the rest of the pulp with Pale Vermilion.

Define the crisp edge of the bottom of the melon slice with the dark of the shadow. Use a blunt point, heavy pressure and multidirectional stroke to go over the shadow with Cool Greys: 90% in the darkest area, 70% next and 50% in the lightest areas. Add a little Tuscan Red over the gray under the melon. Use sharp Verithin Tuscan Red and Indigo Blue to sharpen the edge of the shadow at the melon. To soften the outer edge on the left side go over it with Cool Grey 10%. The right side is a little too purple so go over that edge with Light Ochre and Sand, then Cream to soften the edge.

5 Finish the Side of the Melon

Apply a heavy layer of Yellow Ochre over the rind area at the bottom of the cantaloupe. Use a linear stroke from outside to inside to bring the Yellow Ochre up into the orange of the melon. Apply Limepeel over the Yellow Ochre with the same stroke, letting it go up into the melon. Add a little Grass Green for the darker green areas. Go over the side of the melon with Yellowed Orange and Orange, applying the color more densely in the darker areas. Finish the rind on the left with a little Bronze and Marine Green over the Yellow Ochre. Complete the darkest area of the rind on the right side with Yellow Ochre, Bronze, Marine Green and Dark Umber.

With a sharp craft knife scrape out the tiny highlights and cover them with White. Always touch up the highlights with White as the last step.

KEEP YOUR HANDS OFF!

Use a piece of paper under your hand as you draw to prevent color from getting on your hand and transferring to your drawing surface.

apple with crock

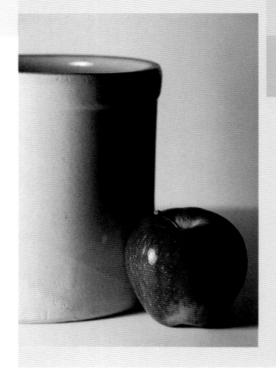

This demonstration deals with two different shiny surfaces. The apple is very smooth and slick. The crock shines with glaze, but it has a pitted surface. The light creates a beautiful reflection of the apple on the side of the crock. Contrast that uses a full range of values creates drama in this simple image.

materials

Prismacolor Pencils

Clay Rose· Cool Grey (30%, 50%, 70% and 90%) · Cream · Crimson Red · Dark Umber · French Grey (10%, 20%, 30% and 50%) · Indigo Blue · Light Umber · Olive Green · Poppy Red · Sand · Scarlet Lake · Spanish Orange · Tuscan Red · Ultramarine · White · Yellowed Orange

Verithin Pencils

Carmine Red · Indigo Blue · Scarlet Red · Tuscan Red

Other

Flat brush · Pearl Gray Stonehenge paper · Solvent

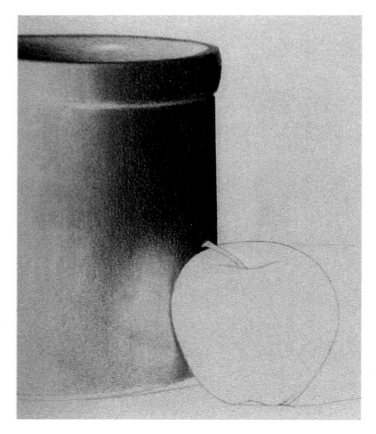

1 Begin the Crock

The position of the stem in the photo is kissing the edge of the apple and crock. Move the stem above the apple and onto the crock to improve the composition. The crock is the perfect candidate for solvent. Since it is the same color as the gray paper, you need only to add shading to contour the shape. Because you'll blend the color with solvent later, you don't have to apply it carefully.

Use a sharp point, medium pressure and vertical stroke on the right side of the crock with Cool Grey 90%, gradually lightening the pressure to fade it out as you move to the left. With Cool Grey 70%, overlap the 90% on the right, fading out the 70% as it goes to the left. Repeat with Cool Grey 50%. This takes you almost to the middle of the crock. Now switch to French Grey 50%, overlapping the Cool Grey 50%. Continue the same technique with French Grey (30%, 20%, and 10%) as you go to the left. Fade the grays into the apple's reflection area just as you did on the left side. Leave the white highlight on the top of the inside of the crock. Don't worry about the pits in the surface right now.

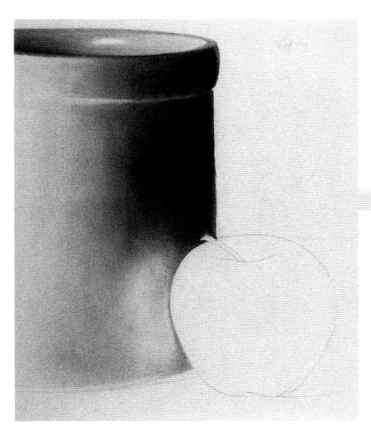

2 Blend With Solvent

Solvent will blend the color for the undercoat. See page 39 for a refresher on how to use solvent.

Use a soft flat paint brush with medium pressure and the vertical and circular strokes to apply the solvent over the colored pencil. You should use so little solvent that you do not have to worry about it bleeding.

WASH YOUR HANDS

After blending colored pencil with your finger, don't forget that you now have color on your finger that you could transfer to another area of the drawing.

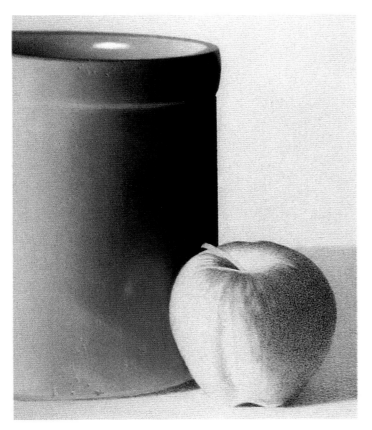

3 Finish the Crock and Begin the Apple

Reapply the same grays from Step 1 with heavy pressure and a blunt burnishing point except around the edges. Use a sharp point there. With the multidirectional stroke, begin on the light left side and work to the right overlapping and blending the different grays. Soften them into the apple reflection area. Use your finger to help blend. Add the beautiful spot of bright blue in the dark side of the rim with Cool Grey 50% then Ultramarine over that. Soften with Cool Grey 90%. Cover the white highlight with White.

Apply a light layer of Scarlet Lake with a little bit of Spanish Orange over the light grays for the apple reflection. Burnish with French Grey 30% using heavy pressure and a blunt point. Bring the surrounding grays into this burnished area. Add the white highlight of the apple to the reflection with White and tone it down with French Grey 30%.

Define the small unglazed bottom rim on the crock with Sand, Cream, Light Umber, and French Grey 30% and 50%. With a very sharp pencil, add dots and imperfections with Cool Grey 90%, 70% and 50%. With French Grey 10%, draw half moons on the right side of the dots to give depth to the imperfections.

Use a sharp point, linear stroke and light pressure to begin contouring the apple with Indigo Blue. Fill in the deep shadow on the right side with a dense layer of color and a sharp point. Define the cast shadows under the crock and apple with Indigo Blue, fading into Cool Grey 50%, then 30% for the rest of the shadow.

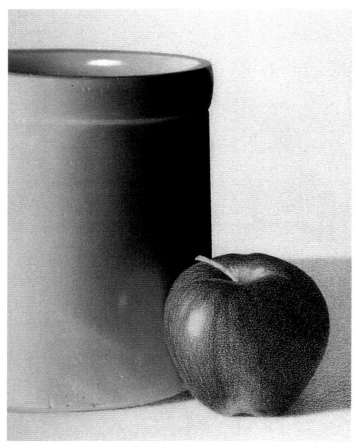

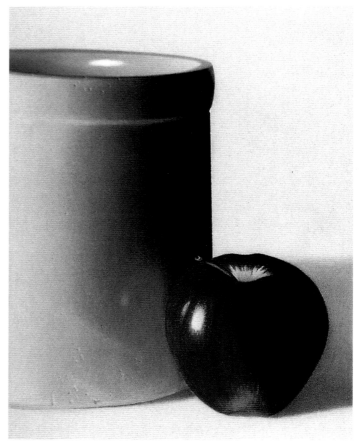

4 Continue the Apple

Using the same points, strokes and pressure as Step 3, apply a layer of Tuscan Red over the Indigo Blue. Define some of the apple's stripes with Tuscan Red. Apply Spanish Orange to the bottom center with Yellowed Orange extending off that up into the middle. Apply some Yellowed Orange to the left side. Around the stem use Cream and Sand and a little Olive Green. Apply Poppy Red to the rest of the apple. Go over the yellows, leaving the white areas and highlights. Let the Poppy Red overlap onto the Tuscan Red. Cover the Tuscan Red areas with a layer of Crimson Red. On the cast shadows cover the Indigo Blue with a very light layer of Tuscan Red fading into Clay Rose.

5 Burnish the Apple With Color

Burnishing will create the smooth shiny surface of the apple. Burnishing with color, rather than colorless blender or White, will create intense color more quickly. Burnish with Yellowed Orange using the linear stroke over the areas where there is Spanish Orange and Yellowed Orange. Then burnish these areas and the entire left side of the apple with Poppy Red. Fade the Poppy Red into the Yellowed Orange at the bottom of the apple. Burnish the dark shaded areas where the Tuscan Red is with Crimson Red. Cover the highlights beginning in the middle and fading out into the red with White.

Apply another layer of Clay Rose before burnishing the cast shadows with Cool Grey 50% in the darker areas and Cool Grey 30% in the lighter areas. Use French Grey 10% to soften the upper and lower edges of the shadow.

With your finger, rub a little of the red from the apple onto the shadow. Begin the stem with Dark Umber over Indigo Blue on the dark side and Sand with a little Olive Green on the light side. Use a very sharp point for this tiny area.

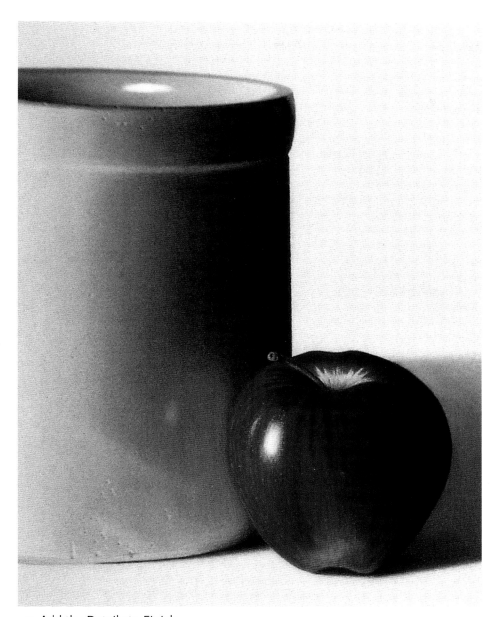

6 Add the Details to Finish

Finish the cast shadows first. Reapply a heavy layer of Indigo Blue and Tuscan Red under the crock and apple, fading as you go up the shadow. Burnish these with Cool Grey 90% in the dark areas, then French Grey 50%, 30%, 20% and 10% over the rest of the shadow.

Add stripes to the apple. Stripe Yellowed Orange around the area of the highlights, then come back in with Crimson Red and Tuscan Red to add more stripes. Darken the shaded side of the apple with a heavy layer of Indigo Blue on the right and center of the area, letting it fade out lighter as you go left. Go over this with Tuscan Red. Apply some stripes with Cream on the left side of the dark area. Cover those with Crimson Red. With sharp Verithin Carmine Red, Scarlet Red, Tuscan Red and Indigo Blue pencils, go over the edges of the apple to make them very sharp.

money plant

The whisper thin inner membrane of the seed pod of the commonly named money plant (also known as silver dollars) is a good item to use to study the effects of light coming through a transparent object. This delicate money plant can be seen in still-life paintings with oriental themes to country themes. It is quite exquisite especially when bathed in light.

materials

Derwent Artists Pencils
Burnt Yellow Ochre

Prismacolor Pencils
Cool Grey (10%, 20%, 30% and 50%) • Dark Brown • Dark Green • Indigo Blue • Non-Photo Blue • Peacock Green • Sienna Brown • White

Verithin Pencils
Green • Indigo Blue

Other
Kneaded eraser • White Stonehenge paper

DO THE BACKGROUND FIRST

When creating a dark background, it's a good idea to do it first. The layers and the heavy pressure used to make darks create a lot of staining pencil dust. Even with constant brushing, the rest of your drawing may need to be cleaned. You can easily erase extra color from blank paper. But if a light object is already drawn with light colors, it could easily be stained by the background dust and will be almost impossible to clean.

REFERENCE PHOTO

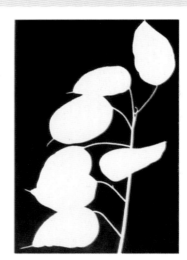

1 Create a New Drawing
Because there are some very thin stems and delicate points on the money plant, go over your original pencil drawing with very sharp Verithin pencils: Indigo Blue and Green. Keep in mind that the stem is inside the line you are creating, it is not the size of the line.

2 Create the Background
Burnish Indigo Blue on the top two-thirds and Dark Green over the bottom third of the background. Use a sharp point around the money plant and a blunt burnishing point over the rest. Apply Dark Green with heavy pressure and the multidirectional stroke. Ease the pressure and fade the green into the Indigo Blue. Apply Indigo Blue lightly over the green, then heavier as it becomes blue only. The right side shows how the Dark Green fades out before the Indigo Blue is applied. Turn your work to avoid putting your hand over areas already covered. Brush often to avoid contaminating the blank areas.

3 Begin the Money Plant

Press a kneaded eraser between two fingers to create a thin razor-like edge, then tap it along the delicate stems and edges of the plant to make sure there is no blue or green dust on those white areas. If you miss any color, it will appear when you add the lighter ones.

With a sharp Derwent Burnt Yellow Ochre, outline the pods and the lines that extend into them. Leave the white highlights on the outer edges. Add this color to the stems and use light pressure to apply it to the tan of each pod, denser where you want darker color and lighter in other areas. With Cool Grey 10%, 20%, 30% and 50%, add the gray areas that you see on some of the pods. Darken the Burnt Yellow Ochre lines on each pod with Sienna Brown.

4 Burnish the Money Plant

With a blunt point and fairly heavy pressure, burnish the inside of each seed pod with White.

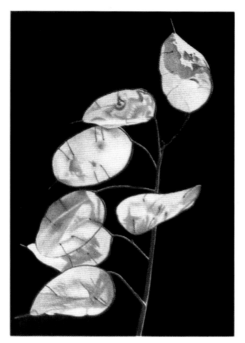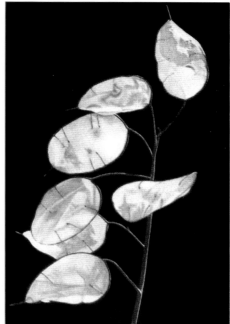

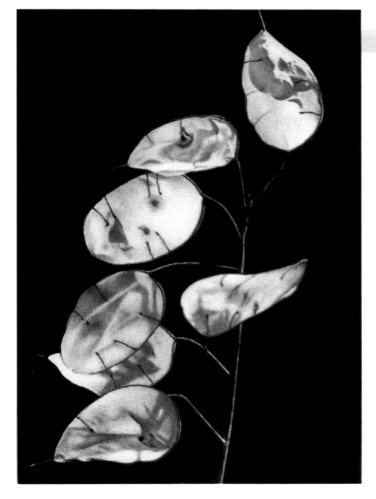

BURNISH LIGHT COLORS WITH WHITE

Generally, when you use light colors, you can't layer too densely or your color becomes too dark. Fewer layers mean less color. Less color causes colorless blenders to leave a grainy look. White blends the lightly layered colors better for a smoother look.

5 Revitalize the Color and Add the Highlights

Reapply colors in Step 3 to your plant. Use a sharp point with medium pressure to add a little zip to the gray shadows with a hint of Non-Photo Blue and Peacock Green. With a very sharp point put in the White highlights on the edges and then a little Dark Brown to darken the stems and spots in a couple of the pods.

This dark background will get wax bloom very quickly. Buff it off and spray the painting with fixative to keep it away. Create a small point on the buffing cloth to get into the small areas, being careful not to get color onto the money plant itself.

STEP-BY-STEP demonstration
orchid

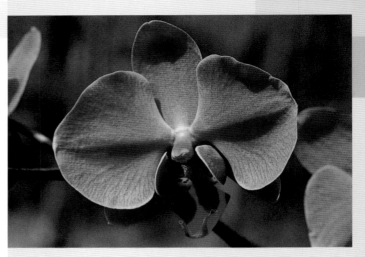

The exquisite simplicity and beauty of the orchid makes it a favorite subject of artists, myself included. This particular variety has brilliant color with tiny white edges best shown off against a dark background. Solvents will help create an impressionistic background, which will contrast beautifully with the crispness of the orchid.

materials

Prismacolor Pencils

Black · Black Grape · Bronze · Clay Rose · Cream · Dark Green · Dark Umber · Grass Green · Hot Pink · Indigo Blue · Lavender · Marine Green · Mulberry · Peacock Green · Process Red · Sand · Sunburst Yellow · Tuscan Red · White

Verithin Pencils

Green · Indigo Blue · Olive Green · Tuscan Red

Other

Artist's tape · Cotton swabs · Craft knife · Flat brush · Paper towels · Solvent · White Stonehenge paper

Apply colors in a random, abstract pattern.

Blend with solvent.

USE TAPE TO DEFINE YOUR OUTER EDGE

Since the background will be blended with solvent, you might find it helpful to define the outer edge of the picture frame with white artist's tape as many watercolor artists do. Then you can brush the solvent right over the edge of the tape and still keep a nice crisp edge when the tape is removed.

1 Begin the Background

Lightly go over the drawing with a sharp Lavender pencil. You'll define the outer edge of the orchid with the background. Loosely apply Tuscan Red, Indigo Blue, Dark Green, Peacock Green and Marine Green over the background in an abstract pattern. Use fairly heavy pressure and a dull point.

Blend the color around the orchid's edges with a small flat brush and a very small amount of solvent. Blend the rest of the background with a cotton swab dipped in a little solvent. Wipe the excess solvent on a paper towel and go over the background in a circular motion. You may repeat this process several times, but be sure to let the solvent dry between layers.

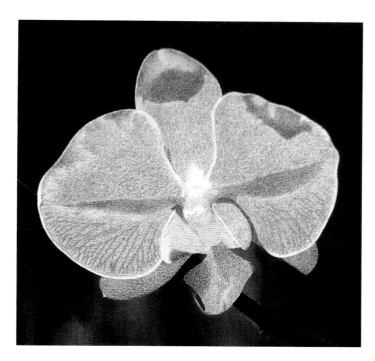

2 Finish the Background and Begin the Orchid

With the multidirectional stroke and fairly heavy pressure, apply the colors from Step 1 over the background. Your pencil point can be dull except where you go around sharp edges. With the same dull point and pressure, apply Sand, Bronze and Clay Rose to the lower part of the background. Use a very sharp Verithin Tuscan Red, Indigo Blue, Green and Olive Green to make the orchd's edges sharp and crisp. If you added it, remove the tape from the edge of the picture frame now.

Apply Indigo Blue with heavy pressure to begin the stem. Use a sharp point and linear stroke going the same cirection as the stem. In the same way, cover the Indigo Blue with a heavy layer of Dark Umber. Add the highlights along the stem's top edge with a sharp White pencil over the Indigo Blue and Dark Umber. Add a touch of Grass Green to the White to soften it. Add a little Black to the stem's bottom edge.

Use a very sharp point with light pressure and the multidirectional stroke to define the shadows of the orchid's foundation with its complementary color Grass Green. Create denser areas of color in the darkest shadows and thinner areas in the lighter shadows. In the area just below the center of the orchid put in a light layer of Sunburst Yellow. Using a very sharp pencil, go over the veins of the petals with Lavender. Put a light layer of Hot Pink over the rest of the orchid, leaving the white areas and edges. Cover this with a light layer of Lavender.

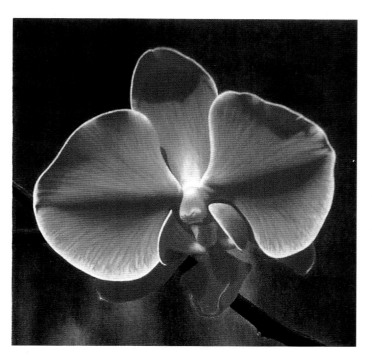

3 Continue the Orchid

Burnish the shaded bottom three petals with Process Red, going over both the green and pink areas. Use the multidirectional stroke and heavy pressure with a sharp point for the edges, then let the point become blunt to fill in the shape. Burnish the green on the remaining main petals with the same Process Red. This time extend it beyond the edges of the green, letting it fade into the veins with a linear stroke. Go over the veins again with a sharp Process Red. Apply a layer of Hot Pink with a sharp point and light pressure in the Process Red areas. When going over the veins, fade it into the White. Burnish the Hot Pink with White. Begin with a very sharp White pencil and go around the edges of the petals, then with the burnishing point and a linear stroke bring the White up into the Hot Pink. Stroke toward the center of the orchid.

On the part just below the center of the flower add another heavy layer of Sunburst Yellow. Go over this with Process Red and White in the appropriate areas.

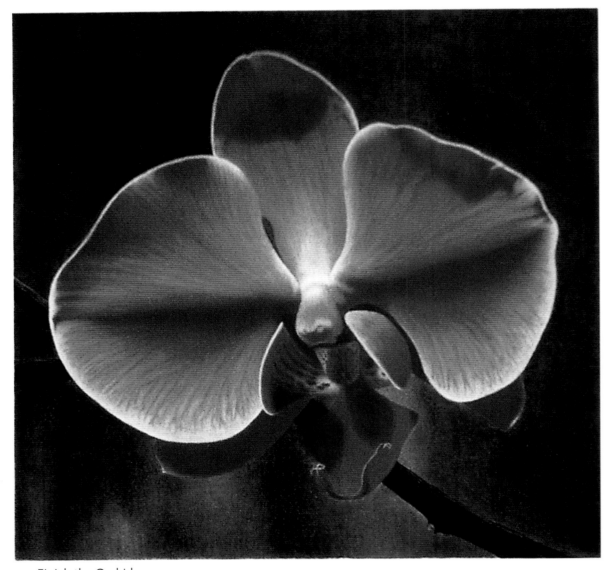

4 Finish the Orchid

The shading on the main petals needs to be darkened. Cover the shadows with a light layer of Black Grape burnished with Mulberry and fade into the petal. On the three bottom petals in shadow, apply a light layer of Tuscan Red burnished with Mulberry. Hit the tips with White. Deepen the deepest shadows around the center and spotted areas with light layers of Indigo Blue, then Tuscan Red burnished with Mulberry. Cover the yellow area with a light layer of Mulberry and Process Red, then burnish that with Cream. Do the shadows in this area just like those in other areas. Put in the spots with Black Grape covered with Tuscan Red. To blend the spots slightly, go over them lightly with Mulberry and Process Red. Use a sharp craft knife to scratch out the squiggly ends on the center bottom petal, then fill them in with Sunburst Yellow and Process Red. Touch up your whites if necessary and the orchid is finished.

rose

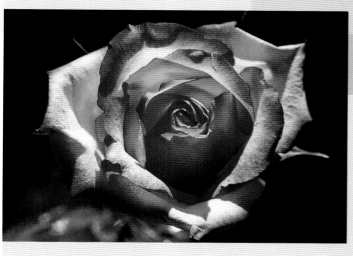

Sunlight passing through the translucent petals makes this rose seem to glow from within. The callouts in this demonstration show you exactly where to place each color to duplicate that glow.

materials

Prismacolor Pencils

Beige • Black Cherry • Bronze • Carmine Red • Celadon Green • Cream • Crimson Red • Crimson Lake • Dark Green • Deco Yellow • Goldenrod • GrassGreen • Hot Pink • Magenta, Mineral Orange • Peacock Green • Sand • Scarlet Lake • Sunburst Yellow • Tuscan Red • White • Yellow Ochre

Other

White Stonehenge paper

1 Create the Background

Apply a thick layer of Tuscan Red with heavy pressure over the entire background. Use a multidrectional stroke with a sharp pencil point for edges and corners, and a less sharp burnishing point for the rest (page 36). This layer is shown in the upper left of the picture. Burnish Peacock Green over the Tuscan Red in the same manner.

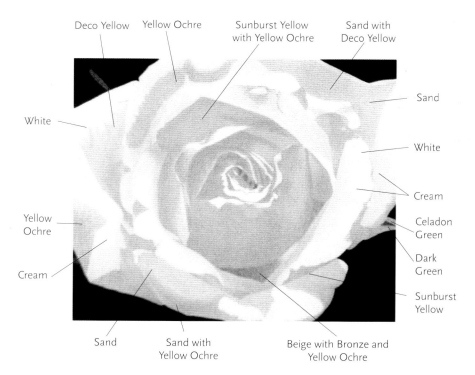

Deco Yellow · Yellow Ochre · Sunburst Yellow with Yellow Ochre · Sand with Deco Yellow · Sand · White · White · Cream · Celadon Green · Dark Green · Sunburst Yellow · Yellow Ochre · Cream · Sand · Sand with Yellow Ochre · Beige with Bronze and Yellow Ochre

2 Begin to Shape the Petals

Define each petal shape with light layers of the lightest color in each area. Use a very sharp pencil point, light pressure and multidirectional strokes to apply all of the color in this step.

3 Finish Defining the Petals

To contour the petals' shapes, begin in the center, gradually going from light to heavier coverage. Layer with a very sharp point and the multidirectional stroke. Use the same colors and techniques to cover similar areas in the rest of the rose. Touch the leaves with a little Magenta.

To finish shaping and contouring the petals, apply color on the tips of the white and Cream areas with strokes going from the outside edge in. Apply color more heavily on the edges, then let them fade away softly by gradually lifting up the pencil.

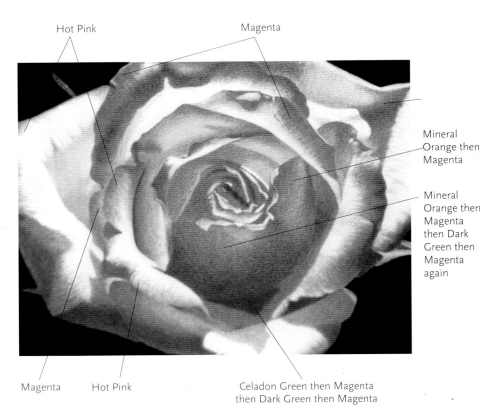

Hot Pink

Magenta

Mineral Orange then Magenta

Mineral Orange then Magenta then Dark Green then Magenta again

Magenta

Hot Pink

Celadon Green then Magenta then Dark Green then Magenta

4 Burnish the Rose

With a multidirectional stroke and heavy pressure, burnish all but the tips of the petals as shown. Use Celadon Green, Dark Green and Black Cherry for the shadow under the center petals and Grass Green for the leaves. Using the same linear stroke as in Step 3, apply White or Cream for the tips of the petals.

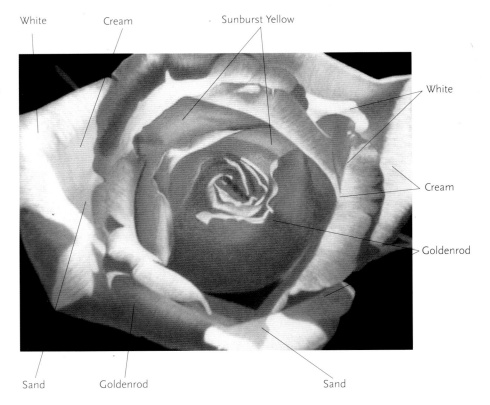

White

Cream

Sunburst Yellow

White

Cream

Goldenrod

Sand

Goldenrod

Sand

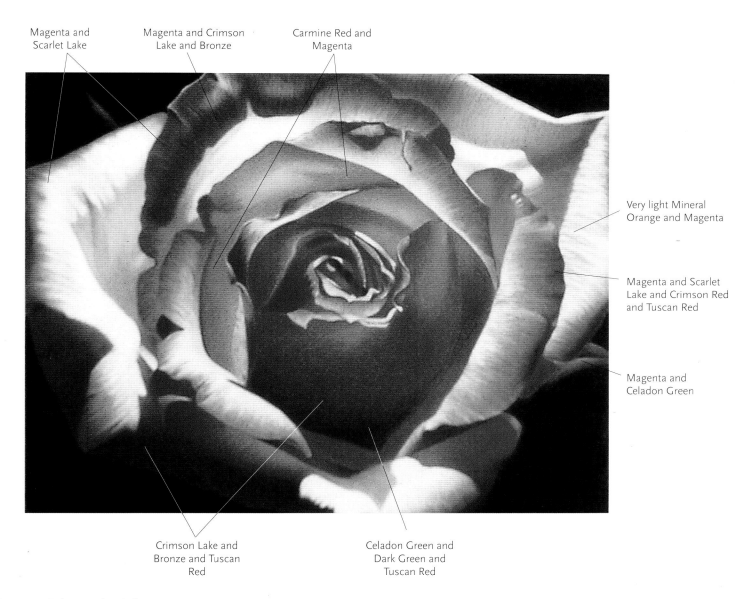

Magenta and
Scarlet Lake

Magenta and Crimson
Lake and Bronze

Carmine Red and
Magenta

Very light Mineral
Orange and Magenta

Magenta and Scarlet
Lake and Crimson Red
and Tuscan Red

Magenta and
Celadon Green

Crimson Lake and
Bronze and Tuscan
Red

Celadon Green and
Dark Green and
Tuscan Red

5 Enhance the Color

When you add the final colors, your rose will really glow. With
medium pressure and the same strokes you used in the last two steps,
reapply color to the rose as shown. Use the colors you that burnished
with to softly blend edges.

If your background begins to look gray with wax bloom, buff and
spray it with a fixative (page 38).

STEP-BY-STEP demonstration
autumn leaves

REFERENCE PHOTO

Nothing compares to the beauty and color of autumn leaves. Sunlight sparkling through the colorful leaves creates a stunning display of nature's glory. This demonstration will show you how to capture this display of light and color as seen in the reference photo of a dogwood branch in autumn sunlight. You'll simplify and darken the background to enhance the light and brilliant color.

materials

Prismacolor Pencils

Black • Burnt Ochre • Canary Yellow • Carmine Red • Copenhagen Blue • Cream • Crimson Lake • Dark Green • Dark Umber • Deco Pink • Indigo Blue• Light Umber • Limepeel • Olive Green • Peacock Green • Poppy Red • Scarlet Lake • Spanish Orange • Sunburst Yellow • Terra Cotta • True Blue • Tuscan Red • White • Yellowed Orange

Other

Mounting putty • White Stonehenge paper

1 Simplify the Background
Apply True Blue, Copenhagen Blue, Limepeel, Peacock Green and Tuscan Red with a dull point and large vertical strokes in a quick random manner. Put the Tuscan Red where the darkest areas should be. Use a sharp point around the edges of the leaves and branches. Apply a lot of color with fairly heavy pressure.This stage does not need to look neat except for those edges.

2 Burnish the Background

With a blunt burnishing point and heavy pressure, burnish the entire background with Peacock Green using the vertical stroke to simulate trees. Blend the colors slightly by rubbing them with your finger.

Because of all the burnishing and rubbing, the leaves are probably slightly tinted with Peacock Green. Form a point with a piece of mounting putty and tap it over the leaf area to remove this tint before you begin the leaves. If your original pencil drawing included details inside the leaves, this will probably remove most of it, which you'll have to replace. I sometimes leave detail out until I've finished the background for this reason.

3 Begin the Leaves

With a sharp point, light pressure and multidirectional stroke, apply Olive Green on the leaves on the left and bottom that have green in them. Use Light Umber on the leaves with brown in the middle right. Use Burnt Ochre for the leaf with orange in the upper middle back. Once you've defined the veins and shadow areas, go over those and the rest of the leaves, except for the white highlights, with Canary Yellow. Lightly layer Dark Umber on the stem and Poppy Red on the berries. Use Olive Green and Light Umber on the small, spent berry stems around the berries.

The Peacock Green burnishing dominates the background a bit too much and doesn't blend away as much as I would like. However, it will be simple to fix. Go over the entire background with a layer of Black using a slightly dull point and the vertical stroke. Because the background has been heavily burnished, some colors will not adhere to the area, but the Black will.

4 Continue to Define the Leaves

Continue to add color and define the leaves using the same sharp point, light pressure and multidirectional stroke. On the leaves with Olive Green, cover the shadow areas with Tuscan Red in the darkest areas and Carmine Red in the lighter areas. Add Poppy Red for the bright red parts of the leaves, making it denser or lighter as needed. Put Limepeel over the area of the veins. On the dying leaves with Light Umber, use Terra Cotta, Poppy Red and Dark Umber with a small circular stroke to mimic their spotted look. On the Burnt Ochre leaf add Scarlet Lake. Apply Scarlet Lake and Tuscan Red to the berries. Touch the darkest part of the main full berry with Indigo Blue. Add a little Olive Green to the stem and Scarlet Lake around the berries.

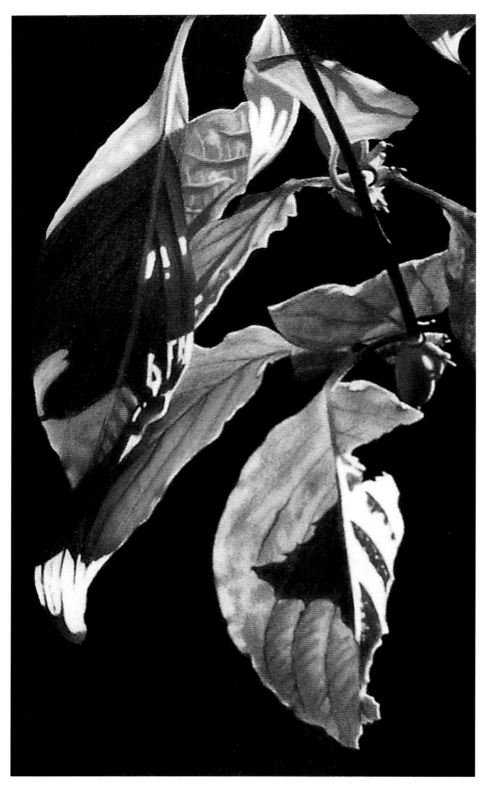

5 Finish the Leaves, Stem and Berries

Burnish all of the leaves, except for the two center right dying leaves, with Sunburst Yellow. Use Cream in the lighter parts and White in the brightest highlights. For the two dying leaves use Spanish Orange in the lighter parts and Yellowed Orange in the darker ones.

With a sharp point and light pressure reapply color over the burnishing. Add Dark Green in the darkest areas of the leaves' shadows, Olive Green in the medium areas and Limepeel in the lightest shadow areas. Apply Tuscan Red, Crimson Lake or Carmine Red between the veins. On the side of the bottom left leaf, burnish between the veins with Deco Pink. On the yellow portions of the leaves add Crimson Lake and Carmine Red. Touch the veins in the yellow areas with Limepeel, Olive Green or Dark Green. Reapply Dark Umber and Terra Cotta to the two dying leaves, then add just a touch of Carmine Red in the brightest spots to make them shine. Cover the shadows on the underside of the orange leaf with Limepeel, Carmine Red, then Yellowed Orange. Define the top of the same leaf with Carmine Red. Darken the one shadow that goes down the bottom of the leaf with a little Olive Green and Carmine Red.

Burnish the berries with the same colors from Step 4. Then fill in the highlights with White. With a sharp pencil and heavy pressure, finish the stem with Olive Green on the left side, then Dark Umber on the right.

The background is still too green. Apply a layer of Tuscan Red—Peacock Green's complement—over the entire background with a burnishing point to neutralize it. The lesson is that you can usually come up with a solution to a problem without discarding your work.

shiny green leaf

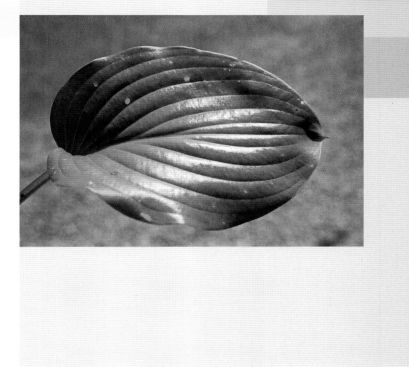

Green is one of the most difficult colors to achieve in any medium. Colored pencil is no exception. It is so easy to make the greens of nature unnatural or garish. This particular leaf is from a white lily. It is good practice, not only for its beautiful green color but also for the many contours formed by the veins.

materials

Prismacolor Pencils

Burnt Ochre · Canary Yellow · Cloud Blue · Cool Grey (10% and 50%) · Dark Green · Deco Yellow · Grass Green · Indigo Blue · Light Green · Limepeel · Olive Green · Tuscan Red · White

Verithin Pencils

Light Green

Other

Colorless blender · Kneaded eraser · White Stonehenge paper

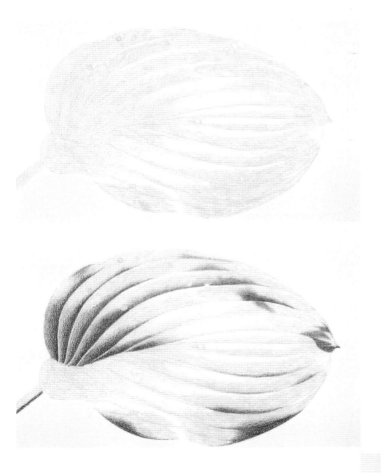

1 Lay In the Foundation for the Leaf

Lightly dab the graphite from your line drawing with a kneaded eraser until you can barely see it, then go over your drawing with a very sharp Verithin Light Green. Do one section at a time so you don't lose the whole drawing. Then, with a very sharp point, light pressure and multidirectional stroke, create a medium-density layer of Canary Yellow, leaving the white highlight areas. The Canary Yellow will help you achieve a realistic green.

A lightly colored background will show off the white highlight areas on the edges of the leaf. Put in a light layer of Cloud Blue with a sharp point, light pressure and the multidirectional stroke. Burnish with Cool Grey 10%. This will give just enough color to contrast with the highlights of the leaf.

2 Add the Deepest Shadows

Using the principle of complementary colors in shadows, lay the darkest shadows with Tuscan Red, the complement to Dark Green that you will add later. Use a sharp point and light pressure. With the multidirectional stroke, make the color most dense in the deep shadows where the leaf meets the vein, then lighten and fade it out as you go away from the vein.

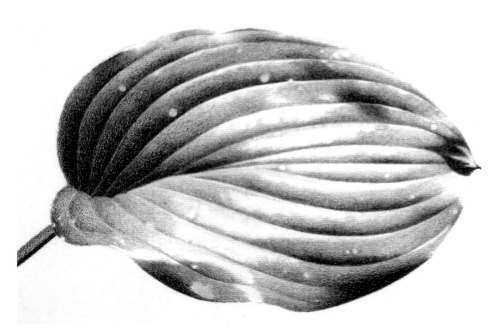

3 Finish the Shading

Define the rest of the shading with Indigo Blue. The blue combined with the base yellow color will begin to give you the first greens. Apply the blue the same way that you applied the Tuscan Red. Go right over the Tuscan Red; these two colors will create the darkest shadows. Then continue to contour the entire leaf with Indigo Blue, making it dense, then fading it out to light.

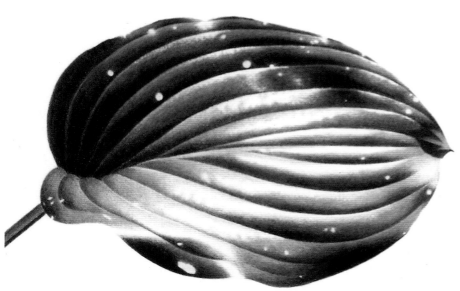

4 Add the First Layer of Green

This entire step will be done with a small blunt burnishing tip and the multidirectional stroke, although you will only need to go a couple of different directions with the stroke. On the dark shadow areas, apply Dark Green over the Tuscan Red and Indigo Blue with heavy pressure. Using less pressure let it fade out into the next darkest areas where you will apply Olive Green with heavy pressure. Use the same Olive Green with less pressure to apply a layer to the lighter areas. Burnish over these lighter areas of Olive Green with Limepeel. Let the Limepeel fade out into the white highlights. These are soft-edged highlights, as seen in the reference photo. Remember to leave the white highlights and brush away the dust created by the heavy burnishing. Touch the white highlight areas with the kneaded eraser. At this point the greens are too yellow, so the last step will be to adjust the green color, deepen shadows and add highlights.

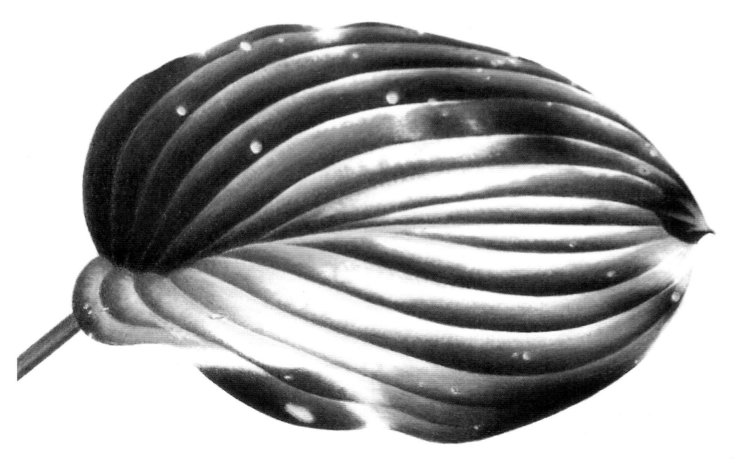

5 Adjust the Color and Add the Highlights and Details

Finish the leaf one rib at a time from top to bottom. Use light pressure to avoid messing up the highlights. Bump up the darks with a light layer of Indigo Blue letting it fade out. Apply Grass Green over the Olive Green areas and Light Green over the Limepeel areas to adjust the green's yellow tint. With a small blunt point lightly burnish all of the green with a colorless blender. With the same point, burnish the highlights with White. Get a crisp edge on the vein letting it blend softly down into the green on the other edge. With a sharp point put a single stroke of Burnt Ochre around the right edge of the holes. On the larger holes put a sharp stroke of White on the left side. With Cool Grey 50% darken the inside of each hole. Complete each section of the leaf in the same manner. Use a little Deco Yellow on the tip of the leaf along with Burnt Ochre.

Finally, if some green has gotten onto the background, lightly skim a kneaded eraser over the green around the leaf. Then simply reapply a little Cool Grey 10% and you're finished.

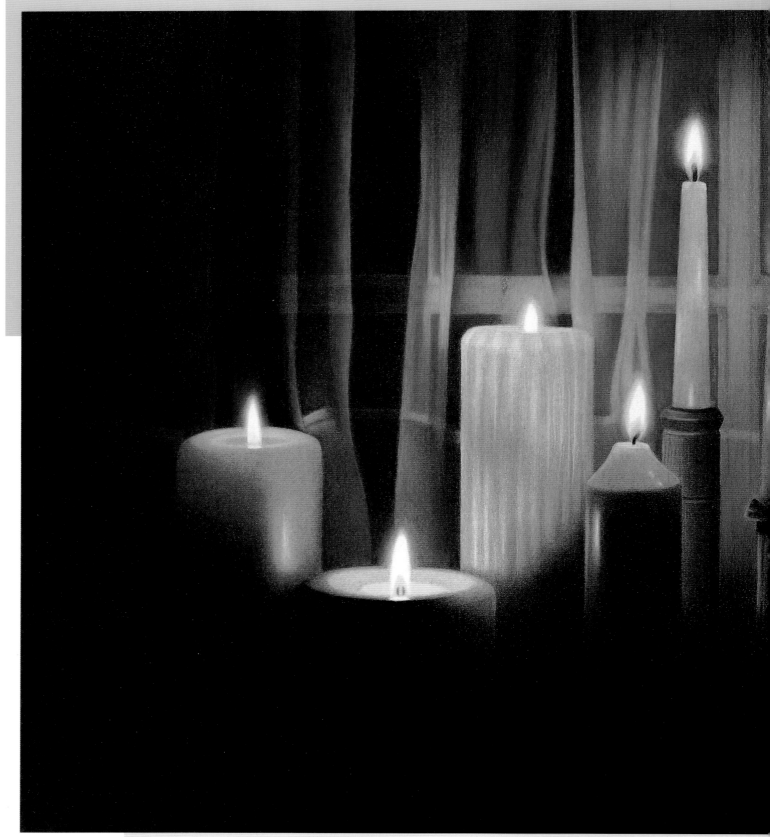

Burning Bright
Colored pencil on white Stonehenge paper
11" × 14" (28cm × 36cm)
Collection of the artist

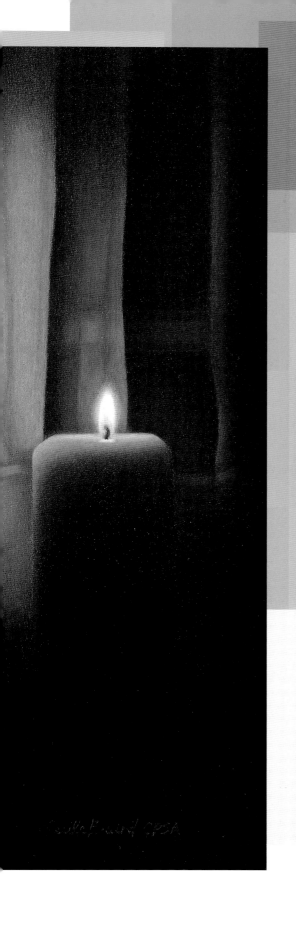

CAPTURE LIGHT & WATER

Most artists are intrigued with light and water from light shining through a bottle or the flicker of a candle to water pooled on the floor or spraying from a fountain. This chapter is devoted to capturing the glow of light and the transparency of water.

Using the layering and burnishing techniques you've learned already, you'll create a single flame and its play on the glass of an oil lamp, the soft tints of lighted blue glass, glowing shadows, and transparent, reflective water.

STEP-BY-STEP demonstration
capture candlelight

The soft flickering light of a burning candle produces a mood and a life of its own. This demonstration will help you to capture the ethereal candlelight in your paintings. The only light source is the candle's flame, which highlights parts of the candle and lets the rest blend into the surrounding darkness. This creates lots of lost edges, the edges of objects that are soft and fade away. Remember to create dense colors with layers, not with heavy pressure.

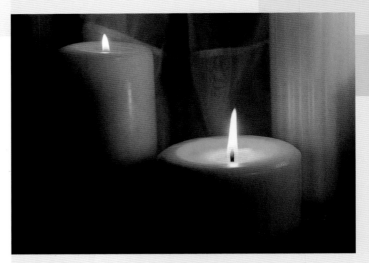

materials

Derwent Artists Pencils

Burnt Yellow Ochre

Prismacolor Pencils

Black · Burnt Ochre · Canary Yellow · Dark Umber · Indigo Blue · Mineral Orange · Pale Vermilion · Spanish Orange · Tuscan Red · White

Other

Fixative · White Stonehenge paper

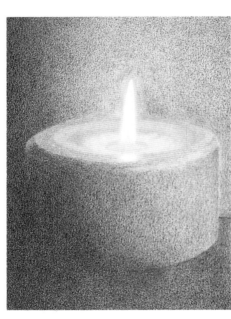

1 Add the First Layers of Color

Use a sharp point, light pressure and multidirectional stroke to add your first layers.

Define the glow around the flame with Canary Yellow. Enhance the flame's glow outside the candle with Canary Yellow, Spanish Orange and Pale Vermilion.

Apply Indigo Blue to the background, fading it into the lighter part of the candle and as it goes toward the flame.

2 Add the Second Layers of Color

Use the same pressure and stroke as in Step 1. You only need to stroke in a couple of different directions to get even coverage for this layer.

Layer Tuscan Red over the Indigo Blue, fading out a little beyond where the Indigo Blue faded. Apply Burnt Ochre from the right side of the candle, fading into the Tuscan Red and Indigo Blue.

Extend the Pale Vermilion around the flame, then work Burnt Ochre between that and the background. Lightly layer Canary Yellow over the top and center of the candle. Leave the white flame and highlights. Put Canary Yellow in the highlight on the side of the candle. Fill in the top rim of the candle with Mineral Orange. Contour the inside of the candle with Spanish Orange and Mineral Orange.

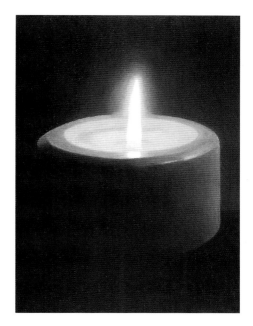

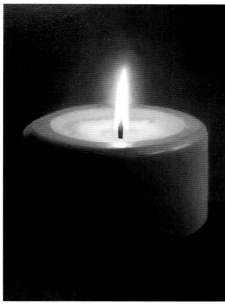

3 Burnish With Color
Use a blunt burnishing point, heavy pressure and the vertical stroke to burnish the top, left and bottom of the background and dark of the candle with Dark Umber. Use Derwent Burnt Yellow Ochre on the far right side of the candle, blending it into Burnt Ochre and Dark Umber.

Apply a dense layer of Dark Umber to the right side of the background, then burnish it with Burnt Ochre, letting this blend into the part burnished with the Dark Umber.

Use your finger to smooth the transition. Burnish the area around the flame with the colors you used in Step 2. Burnish the top rim of the candle with Burnt Yellow Ochre. Add a little Mineral Orange to the inside of the candle; then burnish the entire area with Canary Yellow.

4 Adjust the Color and Add the Highlights
With a blunt point, medium pressure and primarily vertical strokes, apply a layer of Indigo Blue over the dark areas, fading it into the lighter areas. You can use your finger to blend this layer into the background.

Burnish the inside of the candle with White to remove the grainy look. Go back over the inside of the candle again with the colors used steps 2 and 3. Add a touch of Pale Vermilion over the top rim.

Add the wick of the candle with Canary Yellow and Pale Vermilion, then burnish the wick, the entire flame and the white highlight below it with White. Add Black covered with Pale Vermilion to the wick.

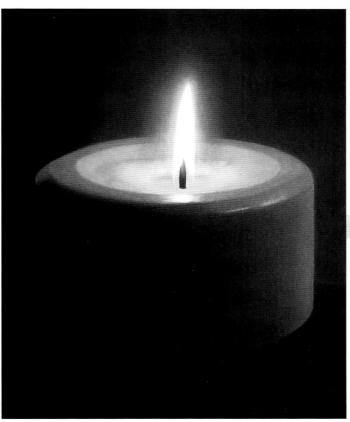

5 Rework the Glow of the Flame
After looking at the finished demonstration for a while, I decided that the flame needed to extend a little into the candle itself. To do this, cover the area around the flame in the candle with a heavy layer of White. Apply Canary Yellow, Spanish Orange and Pale Vermilion over the White. Let this fade out softly into the candle. It is never too late to fix something.

BE CAREFUL WHEN BURNISHING DARK COLORS

You may get wax bloom (page 38) before you are finished, making the darks look streaked. At the end, buff the darks with a soft cloth to remove the wax bloom, then spray the entire picture with two to three layers of UV-resistant fixative. This will make the darks look smooth and uniform and give a nice overall sheen to the picture.

oil lamp

The light from an oil lamp combines the soft glow of the flame with beautiful glass reflections. This combination creates a soft mood when used in a still-life setup. You'll learn to capture the lamp's light while taking advantage of colored paper for the background. The background color shows through the lamp. You'll use this color, and darker and lighter versions of it, to define the glass.

materials

Prismacolor Pencils
Beige • Burnt Ochre • Cream • Dark Umber • Deco Orange • Deco Yellow • French Grey (30%, 50%, 70% and 90%) • Indigo Blue • Light Umber • Peach • Sienna Brown • Sunburst Yellow • Yellow Ochre • White

Other
Colorless blender • Craft knife • Fawn Stonehenge paper • Straightedge • White China marker

REFERENCE PHOTO

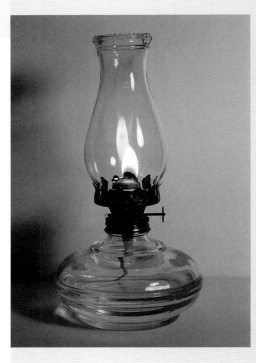

MOUNT YOUR PAPER

Mount your work on a piece of cardboard or other board so you can turn your work as you draw. Your hand naturally draws in one direction better than others and you lose control if you try to force your hand to draw in the wrong direction. It is helpful to be able to turn your work so that you can stroke the pencil in the best position.

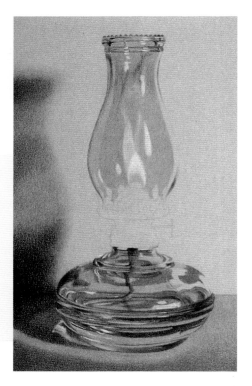

1 Define the Glass and Cast Shadow
Look at each piece of the lamp as an abstract shape. Define those shapes with the various shades of French Grey. Use a sharp point, light pressure and multidirectional stroke.

Fill in the white highlights with White. You would normally save the White until last, but no staining colors are being used, so it is safe to do in this case.

Apply a light layer of Deco Orange next to the wick with a layer of Deco Yellow extending from there up into White to begin the flame. Use Deco Orange and Deco Yellow with a little White over them for the flame's reflection on the back of the globe. Let some Deco Orange and Deco Yellow extend out onto the globe.

Use French Grey 90% over 50% to define the darkest areas on the bottom of the lamp. Use a light layer of Burnt Ochre for the wick.

Lay in the table and cast shadow with the same French Greys and a multidirectional stroke for even coverage.

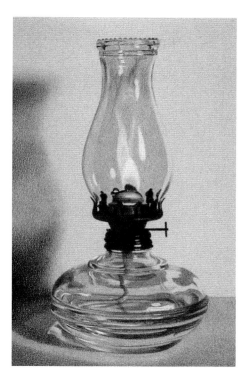

2 Add the Metal

Create the bronze-colored wick holder just below the flame with first Deco Yellow for the highlight, then Sunburst Yellow for the rest. Contour the holder with Burnt Ochre and Sienna Brown. Apply Dark Umber to the darkest areas. Use a sharp point and light pressure and stroke in only a couple of directions with this small area.

Fill in the shape of the globe holder and lid with Dark Umber. Use a very sharp point and light pressure to create a dense layer of color. Leave the white highlights.

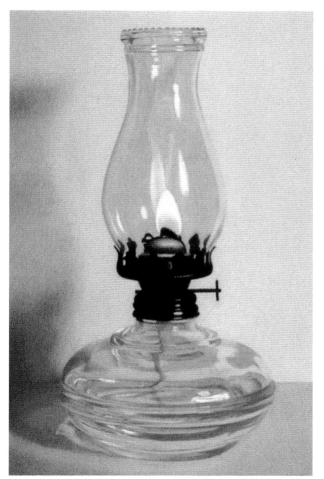

3 Burnish the Lamp

Begin with the globe holder, lid mechanism and wick holder. First burnish with Indigo Blue with a small blunt point and heavy pressure. Then go around the edges with a sharp Indigo Blue. Leave the white highlights. Brush the dust away regularly to keep the color off the white highlights on the glass.

Burnish the stem and wheel that is used to raise and lower the wick with a very sharp Indigo Blue and a straightedge. On the prongs that hold the globe on the back, apply a lighter layer of Indigo Blue to differentiate them from the prongs on the front. Using a sharp pencil and light pressure, go over all of the Indigo Blue with a light layer of Dark Umber to warm up the color of the metal.

Reapply the colors from Step 1 to the bronze wick holder, then burnish the highlight with Deco Yellow, the darkest areas with Dark Umber and the rest with Yellow Ochre.

Glass, Table and Flame Use a blunt point and heavy pressure to burnish all the glass with Beige, then Cream, leaving the white highlights and flame. This combination creates the color of the background paper in the light areas and makes the other grays relate to the paper. Follow the glass contours with your pencil—a vertical curved stroke on the globe and a horizontal curved stroke on the base. Use the same two colors and the multidirectional stroke to burnish the table and cast shadow. Use White for the highlights. After adding a little Peach to the edges of the flame, burnish it with Deco Yellow. Because the burnishing creates a slight sheen that is different from the paper, go over the blank paper areas with a colorless blender, blunt burnishing point and multidirectional stroke to unify the picture.

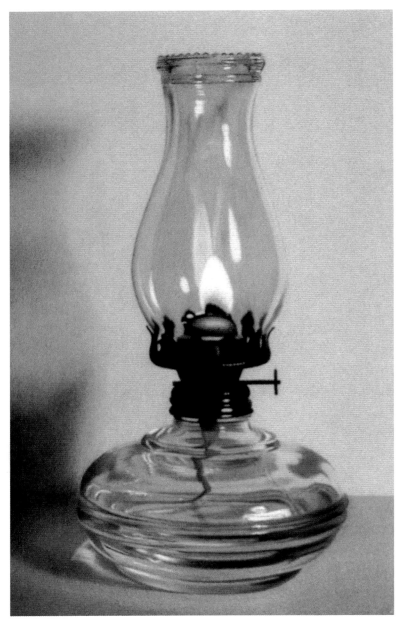

Add the Finishing Touches

With a single stroke define the edges of the holes, ridges and prongs on the lid and globe holder mechanism using French Grey 30% and 50%. Very lightly go over the highlights with a touch of Dark Umber to warm them up. Apply Light Umber on the wick in the bottom glass container, then darken the dark areas with Dark Umber and the light areas with Deco Yellow.

Reapply the colors used in previous steps to bring back the color in the glass, table and shadow. Use light pressure and a slightly dull point until you get the depth of color that you want. Go over the new color with a colorless blender and a blunt point. Stroke in the same direction as your original burnishing—vertical on the globe, horizontal on the base, and multidirectional on the table and shadow. Finally, touch up the white highlights with White, then a White China marker (sharpen the point with a craft knife) to really make them shine.

STEP-BY-STEP demonstration
cobalt blue glass

The bright afternoon sun shining through and backlighting the cobalt blue glass creates an amazing variety of brilliant blues in the glass as well as a very sharp intense shadow. Colored pencil is the perfect medium to capture this brilliance. This demonstration will help you to overcome any fears you might have of incorporating glass into your paintings.

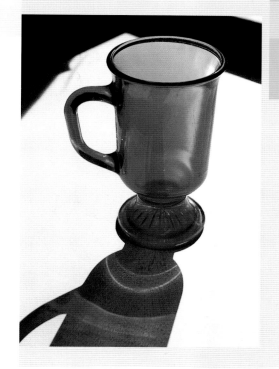

REFERENCE PHOTO

materials

Prismacolor Pencils

Aquamarine · Black · Blue Slate · Deco Blue · Indigo Blue · Light Cerulean Blue · Mediterranean Blue · True Blue · Ultramarine · Violet Blue · White

Verithin Pencils

Ultramarine

Other

Colorless blender · White Stonehenge paper

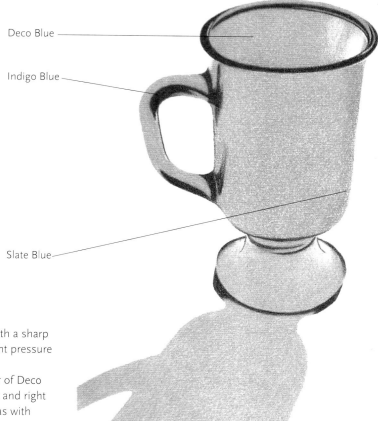

Deco Blue

Indigo Blue

Slate Blue

FOCUS ON SHAPES

The secret to painting glass is to forget that it is glass. Draw the abstract shapes that you see in each section. Think of everything as shapes and colors.

Establish the Basic Shape

Using a multidirectional stroke apply all these colors with a sharp pencil and light pressure. Keep applying the color with a light pressure until you have a dense area of color.

Fill in the shape of the glass and the shadow with a layer of Deco Blue, leaving the white highlights. Use Blue Slate on the left and right side where the reflected light will be. Define the darkest areas with Indigo Blue over the Deco Blue.

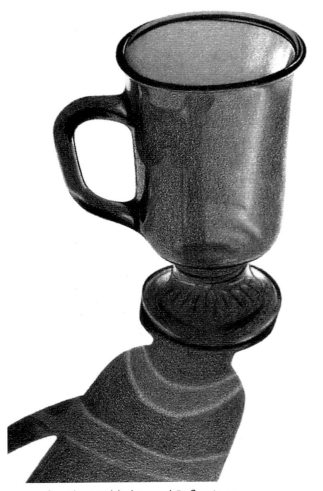

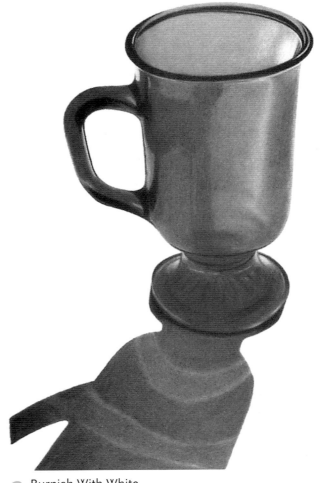

2 **Define the Highlights and Reflections**
Use the same stroke, light pressure, and a sharp point throughout this step.

Apply Light Cerulean Blue over the glass and shadow, softly blending out the edges to form the light blue highlights. Lightly indicate the pattern in the base of the glass with Indigo Blue. Layer Violet Blue over the glass, shadow and dark Indigo Blue shapes. Apply lightly where needed and more densely to form the darker shapes. Leave the inside and the light blue highlights.

3 **Burnish With White**
Always burnish white highlights with a White pencil. Begin in the center of the highlight and fade the white into the color for a soft edge. Burnish the rest of the glass and shadow with a colorless blender using the multidirectional stroke.

WATCH THE PENCIL DUST!

The heavy pressure used to burnish can create quite a bit of pencil dust, so brush often! Indigo Blue and Blue Violet can be very staining if you smear one of these dust specks.

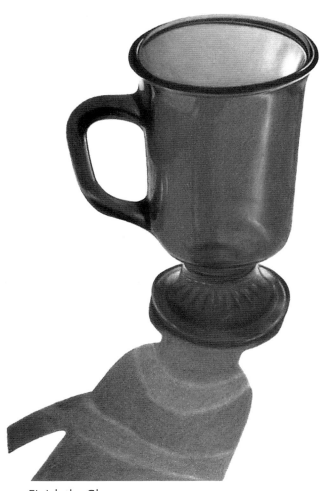

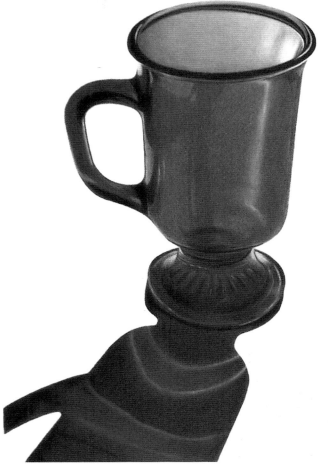

4 Finish the Glass

Applying color over burnishing requires medium to heavy pressure and the same stroke used before. If needed, touch up the white highlights to finish the glass.

Enhance the color on the inside of the top of the glass with Mediterranean Blue. Start heavier at the left and lightly blend out before reaching the white highlights on the right. Cover the light blue highlights softly with Aquamarine, then True Blue. Blend and lighten with White. Cover the dark shapes with Black, then Ultramarine. Cover most of the glass with Violet Blue; apply it heaviest over the intense blue shapes and softer over the lighter blue in the body of the glass. Burnish the lighter blue areas with Mediterranean Blue.

5 Finish the Shadow

Apply a heavy layer of Black over the darkest areas in the shadow then burnish over the Black with a layer of Ultramarine. Cover the highlights with a soft layer of Aquamarine, then burnish with True Blue. Cover the remainder of the shadow with a light layer of Black and burnish that with Ultramarine.

If needed, the edges of the glass and shadow can be sharpened with a colorless blender or a Verithin Ultramarine pencil.

spilled water

Whether in a vase of flowers or spilled on a counter, water is an exciting element to add to your paintings. In this demonstration you'll capture the transparent and reflective qualities of water. Just as with glass, look at water as a series of abstract shapes and colors and draw what you see.

materials

Prismacolor Pencils
Beige · Blue Slate · Dark Brown · Dark Umber · Periwinkle · Tuscan Red · Warm Grey (10%, 30% and 50%) · White

Other
Colorless blender · Stonehenge White paper

1 Define the Water and Tiles
With a sharp point, light pressure and multidirectional stroke, define the water and tiles with a dense layer of Warm Grey 10% in the lightest areas, Warm Grey 30% in the medium areas and Warm Grey 50% in the darkest areas. Leave the white highlights and grout. Then in the same manner cover all of the greys with a dense layer of Blue Slate.

2 Continue to Develop the Water
With a sharp point, multidirectional stroke and light pressure, cover all of the water and glass area except for the white highlights and grout with a light layer of Tuscan Red. Because Tuscan Red is such a strong color this layer should be light. Cover the Tuscan Red with a dense layer of Dark Umber.

3 Burnish the Entire Painting

With a blunt burnishing point, multidirectional stroke and heavy pressure burnish the entire picture. Use Warm Grey 10% on the tile without water, White on the highlights and colorless blender on the rest. Still leave the grout. You'll do that on the final step.

4 Redefine the Water and Glass

To capture the subtle variations in the color of the spilled water cover the lighter areas with a layer of Blue Slate and the darker areas with a layer of Dark Umber. Use a blunt point and medium pressure.

5 Add the Finishing Touches

Begin the grout by putting in the shadows. In the tile without water use Bruynzeel Dark Brown burnished with Beige. In the tile covered with water, use Warm Grey 30% then Bruynzeel Dark Brown burnished with Warm Grey 30%. For the grout without water use Warm Grey 30% then Bruynzeel Dark Brown and burnish with Beige. Add a little Warm Grey 10% over this. For the grout under water use Warm Grey 30% then Bruynzeel Dark Brown burnished with Warm Grey 30%. Since you are working in small areas a sharp point will be necessary. Use heavy pressure when burnishing.

Once all of the darks were completed the uncovered tiles were still too light so I darkened them with a light layer of Periwinkle burnished with Warm Grey 30% and 50% making the tiles darkest at the bottom of the picture and lighter at the top.

STEP-BY-STEP demonstration
water fountain

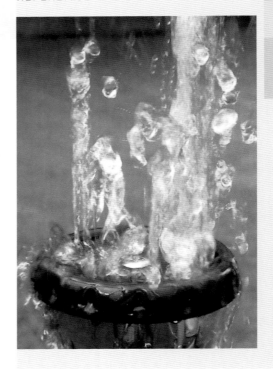

Unlike glass or other transparent things water has the ability to move. As you will see in this demonstration water spraying from a fountain has different characteristics than spilled water on a counter. Some of the transparent qualities of the water are lost because the eye cannot separate the droplets at the speed the water is spraying.

materials

Prismacolor Pencils
Black · Blue Slate · Bronze · Copenhagen Blue · Dark Brown · Dark Green · Indigo Blue · Limepeel · Olive Green · Slate Grey · Warm Grey 30% · White

Other
Colorless blender · White Stonehenge paper

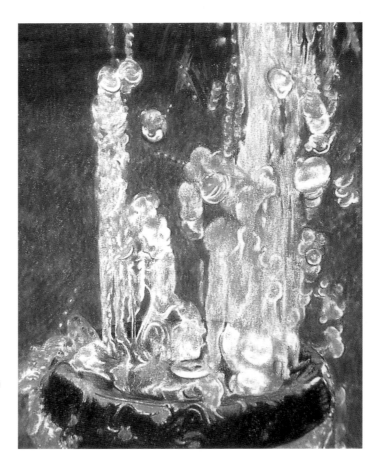

1 **Lay In the Background and Define the Water and Fountain**
Fill in the background first with squiggly strokes of interspersed Olive Green, Limepeel, Slate Grey and Bronze. Use a dull point and medium pressure. Just put in the colors randomly until you have covered the entire background. To make the top of the background darker cover in the same manner with Dark Green then Dark Brown.

Water Against the Background Notice that there a streams of water shooting out of the fountain with a few individual water droplets visible. You can see more of the background through the droplets than you can through the streams. Leaving the white, define the water that is against the background with Olive Green, Warm Grey and Blue Slate. Use a sharp point and light pressure and the multidirectional stroke. Again look at the water as a series of shapes and colors.

Water in Fountain and the Fountain Because water is transparent, the water against the fountain is different than the water against the background. Leave the white and begin to define the water and the fountain with Indigo Blue. Then continue with Slate Grey, Warm Grey 30% and for the very bluest areas Copenhagen Blue. For the darkest part of the rim of the fountain add Black over the Indigo Blue. Apply all of these colors with a sharp point, light pressure and multidirectional stroke.

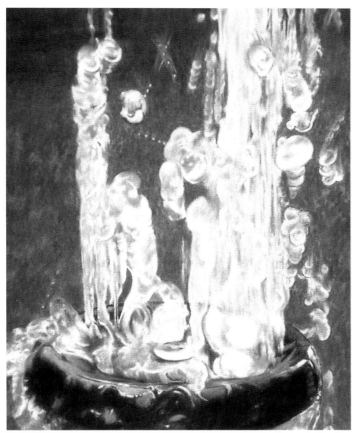

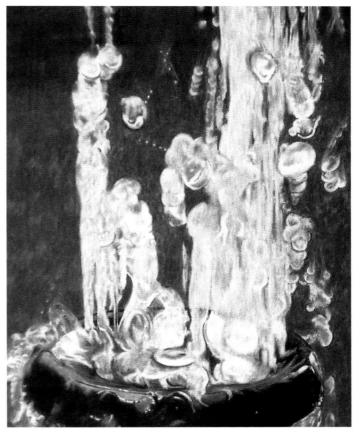

2 Burnish the Painting

Burnish the entire background and the darkest parts of the fountain that are covered with Indigo Blue and Black with a colorless blender using a blunt point and heavy pressure. Because you used medium pressure and big strokes in the first step you will not see a huge difference with the burnishing. It will, however, fill in the remaining white spots of the paper that are showing through.

Now burnish all of the water both in the fountain and against the background with White again using a blunt point and heavy pressure.

3 Reapply Color to the Water

Your background looks great and doesn't need any additional color. Apply another layer of Indigo Blue then Black over the darkest parts of the fountain. Since burnishing with White washed out the details in the water, use the same colors that you used in Step 1 to reapply the colors to the water. Finally use a sharp White pencil to sharpen the water's edges and you're finished!

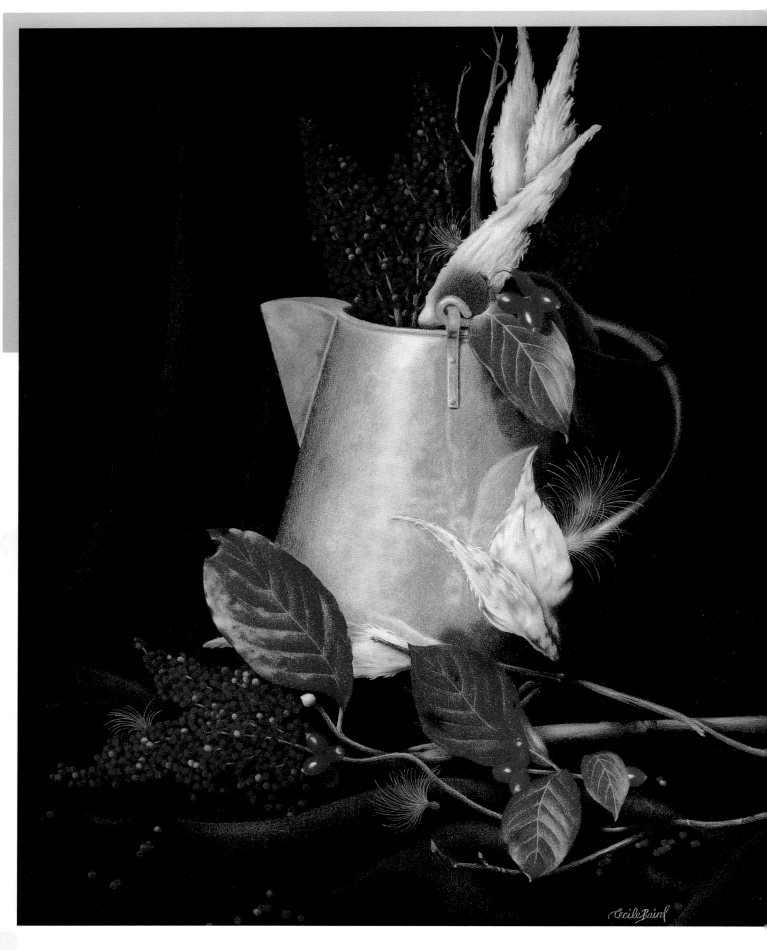

BRING TEXTURES TO LIFE

To create reflections and transparency, it's often necessary to include backgrounds and many, many different layers of color—requiring many, many different pencils. In this chapter, you'll learn to create textures. And you can create most textures with no background, fewer layers and, as a result, fewer pencils.

One of the things I like best about still-life painting is the variety of textures that you get to do. Because colored pencils are so versatile, they are perfect for creating any texture that you encounter.

In this chapter you will learn to capture the plush feel of a rich velvet drape, as well as how to perfectly create the rough texture of a linen cloth. Some dull surfaces, like that of a cast iron kettle, seem to absorb light, while light appears to bounce off shiny surfaces. These step-by-step demonstrations will teach you the versatility of this wonderful medium.

Autumn
Colored pencil on white Strathmore 500 Series paper
18" × 13" (46cm × 33cm)
Collection of Mrs. Janet Butler

STEP-BY-STEP demonstration
copper cup

Like any shiny surface, this copper cup is made up of reflections of its surroundings. Capturing these reflections correctly will make your painting shine like the real thing. To create the color of the copper itself, you might think you could use a metallic copper pencil. But that pencil isn't even close. Look carefully at the cup. What colors do you really see? The dark reflections are purple and contain very cool oranges. Cool oranges contain red, while warm oranges contain more yellow. When beginning any painting, experiment with different colors to decide which will work best.

materials

Prismacolor Pencils

Black Grape · Clay Rose · Cloud Blue · Crimson Lake · Greyed Lavender · Indigo Blue · Metallic Rose · Neon Orange · Neon Red · Terra Cotta · Tuscan Red · White

Other

Colorless blender · White Stonehenge paper

1 Create the Foundation and Define the Darks

Use a sharp pencil, light pressure and the multidirectional stroke for this step. Apply a light layer of Clay Rose over the entire cup except for the white highlights and the inside. Fade the Clay Rose into the white highlights. Treat the bright orange copper highlights like white ones and leave them. Go over the Clay Rose in the lightest reflection and highlight areas on the sides of the cup and around the white highlights with Greyed Lavender.

Put in the dark dings and splotches with Black Grape. Create the next darkest areas with Metallic Rose for a medium muted purple that isn't as intense as some of the other medium purple shades. Apply the color a little unevenly so that it shows the cup's splotchy effect.

Apply layers of the Black Grape until you get the darkest darks. Fill in the area inside the cup with a dense layer of Black Grape, except under the white highlight. Blend some Clay Rose and Metallic Rose in the highlight and in the small shadow under the cup.

2 Apply the Copper Color and Burnish

Apply a dense layer of Neon Orange over the purples, leaving the white highlights. Put in a light layer of the orange around the white highlights and fade it out into the white. Use just enough pressure to cover the previous colors on the rest of the cup with the orange. Use a curved vertical stroke over the body of the cup following the contour. Then, apply color down the length of the handle and horizontally around the rim. Turn your work so that your hand is always going in the most comfortable direction.

Burnish Blend all of the layers of color together and fill in the grain of the paper. Put in the white highlights with a White pencil, heavy pressure and a blunt point. Fade the White into the areas around the highlights. Burnish the rest of the cup with a colorless blender, heavy pressure, a blunt point and multidirectional strokes. Let the colorless blender and White fade into each other.

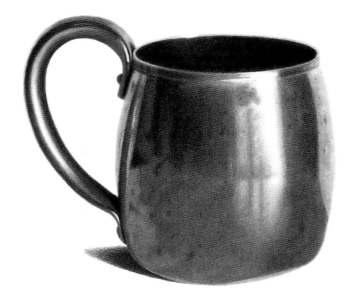

3 Reapply Color to Finish the Cup

Apply a heavy layer of Indigo Blue over the inside of the cup, except for the area under the white highlight in the back. Cover that with Black Grape, then a light layer of Tuscan Red. Apply a light layer of Neon Red over all the areas where you applied Neon Orange to the cup. The Neon Red will adjust the Neon Orange, which is just a little too yellow. Apply a very light layer of Terra Cotta over the medium and dark areas. Cover this with a little Crimson Lake.

Burnish Use Cloud Blue in the light areas around the white highlights and the right and left sides of the cup. Use Clay Rose for the medium areas and Metallic Rose for the darker areas, then Indigo Blue covered with Tuscan Red for the darkest areas. Hit the dings and dents with Black Grape and Indigo Blue. Put Neon Orange over the bright copper highlights and Indigo Blue and Tuscan Red over the shadow. Touch up the white highlights again and you are finished.

cast iron kettle

Because this cast iron kettle is dull and dark, the light hitting it is absorbed and does not create as much contrast as it would on a shiny surface, such as the kettle's coiled handle. The challenge is to create the contour of the kettle with subtle changes between the darkest shadows and the areas receiving the direct light.

materials

Prismacolor Pencils
Black • Burnt Ochre • Cool Grey (10%, 20%, 30%, 50%, 70% and 90%) • Terra Cotta • Warm Grey (30%, 50%, 70% and 90%) • White

Verithin Pencils
Cool Grey 70% • Light Grey • Terra Cotta

Other
Colorless blender • Craft knife • White China marker • White Stonehenge paper

BE CAREFUL WITH COLORLESS BLENDER

Keep your pencil point clean and work from light to dark when using the colorless blender over dark colors to avoid dragging the darks where you don't want them.

1 Cover the Kettle With Rust
Use a sharp point, light pressure and a multidirectional stroke for this step. Using the side of the pencil rather than the point, quickly apply a light layer of Terra Cotta to the kettle.

Once you've covered the entire kettle, apply a dense layer of Terra Cotta to the areas where the rust shows through the cast iron. The Terra Cotta is a little more red than rust, so apply a light layer of Burnt Ochre over it so it looks more yellow.

Begin to apply a dense layer of Black over the darkest areas of the handle.

2 Finish the Darkest Cast Iron Colors

Generally, Black pencil creates a dull, rather than lively, black. Even though dull black is perfect for cast iron, use it in only the darkest areas, such as the inside of the spout and the sides. Use Warm Grey 90%, 70% and 50% to complete the body. Use Warm Grey 30% for the lightest areas, such as the right side of the body and the ridge on the lower portion. Blend one color into the next to create the kettle's contour. Use a very sharp point, light pressure and the multidirectional stroke. As you transition from one color to the next, let the color become less dense and begin the next color by overlapping the previous. Apply the grays over the Terra Cotta from Step 1, leaving the areas where the rust shows. Allow a little Terra Cotta to blend into the grays where they meet. Then put in some Terra Cotta spots on the front of the kettle.

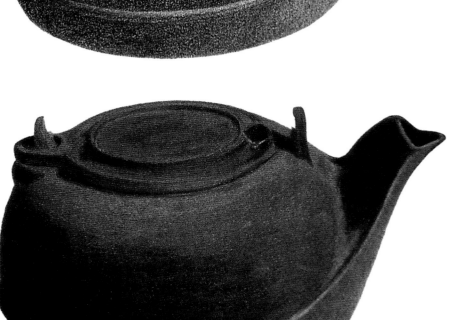

3 Burnish with Colorless Blender

Use a colorless blender to blend the layers and fill in the grain. Use a blunt point, heavy pressure and a back-and-forth, slightly curved stroke that follows the contour over the entire kettle. Lots of dust is created when burnishing these dark colors, so brush often to avoid smearing the dust of your dark colors around your clean paper.

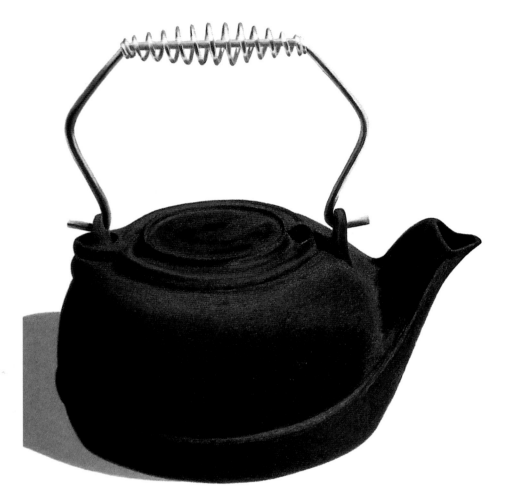

4 Complete the Kettle and Add the Handle and Shadow

Use the same colors you used in Steps 1 and 2 to go over the areas to darken or lighten as needed. Use a sharp point, light pressure and the multidirectional stroke. Go over the rusty area around the lid and the right bottom corner of the kettle with a light layer of Black. Since you have already burnished the area, the dark color will look a little grainy, which is great because it will make the rust look like it is peeling off. Darken the lid and add some highlights with the Warm Grey 30%. Then use very sharp Cool Grey 70%, Light Grey and Terra Cotta Verithin pencils to sharpen up the outer edge of the kettle.

Use heavy pressure and a blunt tip to burnish the kettle's simple cast shadow with Cool Grey 20%. Use heavy pressure and the Prismacolor Cool Greys and White to create the handle. Use a very sharp point to fit into the handle's small spaces. Since the handle is very shiny and reflective, there is no blending. The edges between colors are crisp. When the handle is complete, apply some small touches over the medium areas with a very sharp Terra Cotta pencil to tie the handle into the rest of the kettle. Finally, cut a sharp point on a White China marker with a craft knife to bring out the handle's white highlights.

STEP-BY-STEP demonstration
freshwater shell

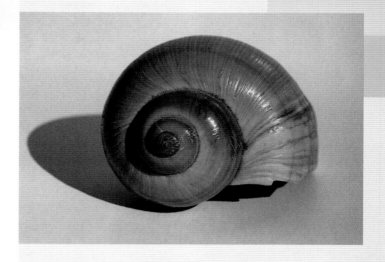

With their amazing shapes, patterns and colors, shells are some of the most challenging and rewarding objects to paint. You don't have to live by the shore to find them either. This freshwater shell has a beautiful spiral shape with stripes running across the spiral and an incredible variety of subtle coloring. The smooth surface of the shell creates great highlights when it is in the sun. Beautiful subjects to paint are everywhere.

materials

Prismacolor Pencils

Black Grape • Blue Slate • Clay Rose • Cloud Blue • Cool Grey (30%, 50%, 70% and 90%) • Cream • Greyed Lavender • Indigo Blue • Mediterranean Blue • Periwinkle • Pumpkin Orange • Sand • Slate Grey • Terra Cotta • Tuscan Red • White

Verithin Pencils

Terra Cotta

Other

White Stonehenge paper

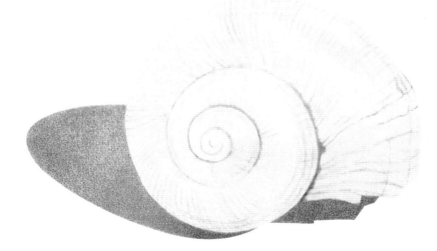

1 Define the Shape

Lightly define the radiating stripes of the spiral with a sharp Verithin Terra Cotta. Use light pressure and a multidirectional stroke to apply a light layer of Cream to the shell. Go over the Terra Cotta lines but leave the white highlights. Apply the cast shadow with Cool Grey 70% under the shell and Cool Grey 50% over the lighter portion.

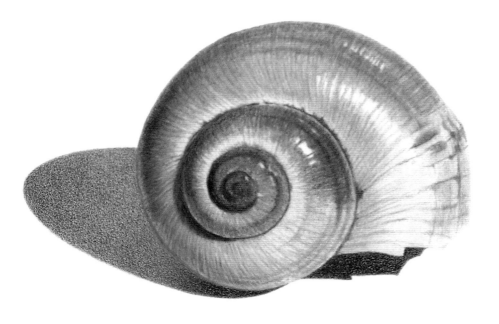

2 Lay in the Basic Color and Contour the Shell

Use a sharp pencil, medium pressure and linear stroke going across the spiral just like the stripes. Beginning on the bottom right side of the shell, apply Cloud Blue and Blue Slate, then Greyed Lavender and Clay Rose in and around the blues. Go over that with Pumpkin Orange and Terra Cotta. Use a little Pumpkin Orange on the inside edge of the spiral. Repeat these colors, but darker or more dense continuing up the spiral. Define the highlights that have a crisp edge on the shiny surface.

Use Slate Grey and Periwinkle on the top outer edge of the shell and Mediterranean Blue on the warmer blue stripe. Use Cool Grey 70% and Indigo Blue for dark shadows. Add Cool Grey 90% and Black Grape over that for the darkest shadows. Continue these colors around the shell. Brighten the blues; even though in the photo the shell has more gray.

In the center of the spiral use Terra Cotta over a light layer of Periwinkle. For the darker areas use Clay Rose, Black Grape and Indigo Blue. Cover the deepest part of the shadow under the shell with Indigo Blue and the lighter part with Mediterranean Blue. Touch Tuscan Red over the Indigo Blue and Black Grape over the Mediterranean Blue.

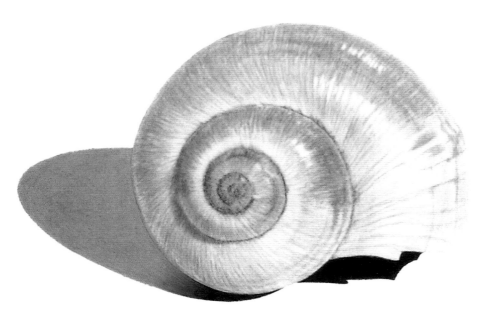

3 Burnish With Color and White

With a blunt point, heavy pressure, and multidirectional stroke, burnish the shadow with and Cool Grey 30% and Indigo Blue in the dark area. Then use White for the entire shell. Following the contour of the shell, stroke in the same direction as in Step 1. Burnishing with White is a little scary because you lose all of the color you just put down. But this creates the smooth look of the shell.

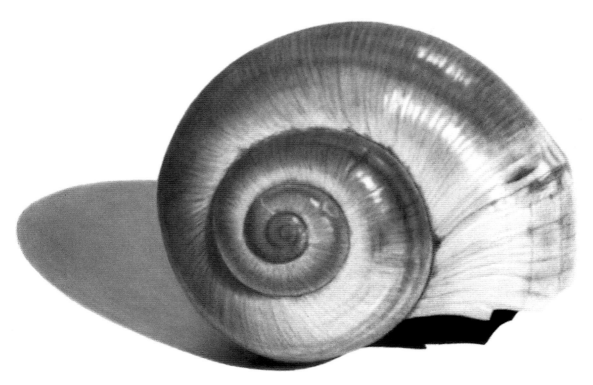

4 Reapply the Color and Add the Details

Now that you've created a nice smooth shell, reapply the color. Use the same colors and strokes as Step 2. Apply the colors, then lightly smooth them out with a lighter color. For instance, smooth Terra Cotta lightly with Clay Rose, Blue Slate with Periwinkle, etc. This doesn't require heavy burnishing but only a light smoothing. The only color that you need in this step that you didn't use in Step 3 is Sand, which you add to some of the creamy areas.

To finish the shadow, apply a light layer of Black Grape over the lighter part, then burnish it with Cool Grey 50%. Burnish the darker area with Tuscan Red, letting it and the Cool Grey blend together. Finally, hit the highlights one last time with White. Go over the shell's edges with a sharp White pencil, letting it straddle the edge of the shell and the white paper.

weathered wood box

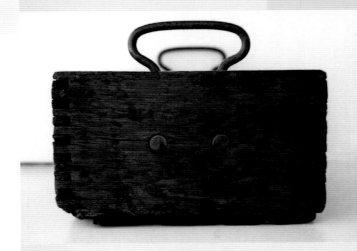

Wood texture is frequently found in paintings, from tables to baskets. Your still life may be sitting on a highly polished walnut table, or fruit may be displayed in a tropical wooden bowl or on old painted and peeling wood furniture. You'll learn how simple painting wood realistically can be with this end of an old wooden box with dovetailed corners, nails and splits.

materials

Derwent Artists Pencils
Burnt Yellow Ochre

Prismacolor Pencils
Dark Umber • French Grey (30% and 50%) • Terra Cotta • White

Other
White Stonehenge paper

1 Draw the Box and the Wood Grain
Draw the dovetailed corners, the bottom of the box, the nails, and the grain of the wood with Dark Umber. With a sharp pencil, light pressure and the horizontal stroke, fill in the shapes. Use a sharp point and the horizontal stroke to put in the grain.

2 Continue Defining the Box and Wood Grain
Cover the Dark Umber of Step 1 with a light layer of Terra Cotta. Add some secondary wood grain with Terra Cotta as well. Again use a sharp pencil with light pressure and horizontal stroke.

3 Burnish With Color

Burnish the entire box, except for the nails, with Burnt Yellow Ochre. Stroke horizontally to emphasize the grain of the wood. Use heavy pressure and a blunt point until you come to the edges of the box. There, use a sharp point to define the edges. The Burnt Yellow Ochre will show where there was no Dark Umber or Terra Cotta. Fill in most of the white of the paper. Burnish the two big nails in the middle of the box and the four small nails on either end of the box with French Grey 50%.

4 Reapply Color

Use heavy pressure to reapply Terra Cotta to those areas of the box that will stay that color. Then burnish the Terra Cotta with Burnt Yellow Ochre and reapply more Terra Cotta lightly. Repeat these two until you achieve the desired color. Use the horizontal stroke for these colors.

Use light pressure to reapply the dark wood grain with Dark Umber and darken the bottom of the box, the dovetailed corners, the cracks and around the nails. Add Dark Umber and Terra Cotta to the center nails. Finally, add a highlight to all the nails with French Grey 30%. Go over all the box's edges with a sharp White pencil to sharpen them. Let the pencil touch both the edges of the box and the white paper. This technique can only be used on white paper, but it does create a nice clean edge.

CREATE POLISHED WOOD

Light would reflect differently off of the weathered wood box if it were covered with a layer of glossy shellac. To achieve this look, apply white highlights with a sharp White pencil.

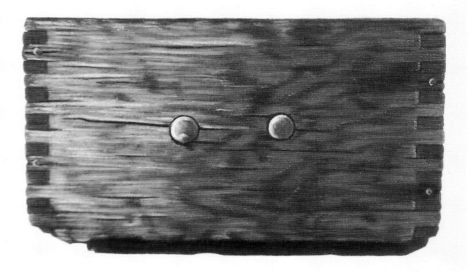

velvet drape

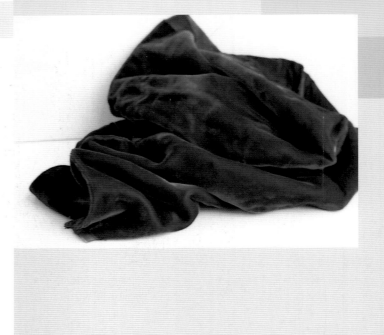

I have always thought that burnished colored pencils look like velvet, so doing a velvet drape for a still life in colored pencil is a natural. The richness of the colors combined with the smooth texture of burnishing captures the look of velvet perfectly.

materials

Prismacolor Pencils

Copenhagen Blue · Deco Blue · Indigo Blue · True Blue · Tuscan Red · Violet Blue · White

Other

White Stonehenge paper

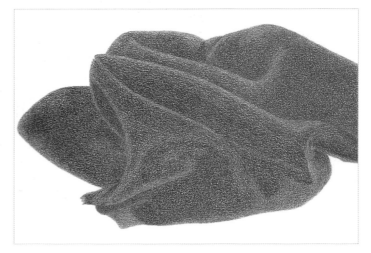

1 Add the First Layer of Color

Using a combination of cool blues (those toward violet) and warm blues (those toward green) gives a nice depth of color to the velvet. Use a sharp pencil, light pressure and the multidirectional stroke to apply a layer of True Blue over the entire cloth. Reapply light layers of True Blue on the edges of the folds to increase the density where the light highlights will appear. Next apply a layer of Violet Blue. Make the color dense in the shadow areas and then fade it into medium density over the medium areas, finally letting it fade into the highlights. Apply some True Blue back over the Violet Blue where the two meet, blending them.

Violet Blue will dominate in the shadows, the two will blend in the medium areas, and True Blue will dominate in the highlights.

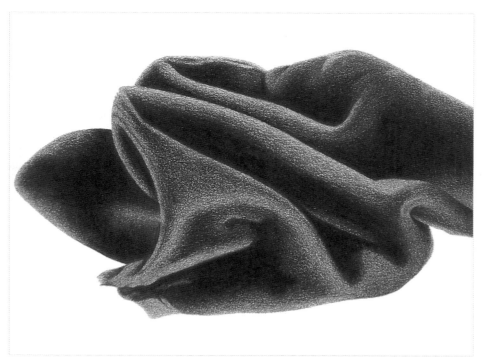

2 Burnish With Color

Color burnishing will bring out the cloth's richness. Use heavy pressure, a blunt point and multidirectional stroke. Begin with the dark shadows, applying the lightest highlights last so the lighter colors aren't stained by the darker ones. Use Indigo Blue for the darkest shadow areas. Lighten up on the pressure and let the dark shadows fade into the middle tones. Use Copenhagen Blue for the middle tones fading it into the darks and fade out lightly in the lightest areas. Finally, burnish the highlight areas with True Blue again, fading it into the Copenhagen Blue.

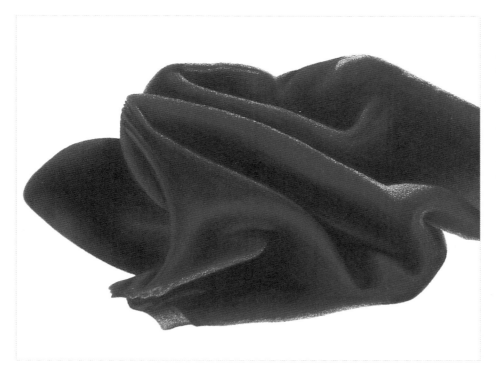

3 Lighten the Highlights and Deepen the Shadows

Add Tuscan Red covered with Indigo Blue to deepen the shadows in the darkest parts and in all shadow areas that are against highlighted edges. Burnish over the highlight areas with Deco Blue, fading it into the True Blue. Apply White over the Deco Blue to create the brightest highlights. On the back left fold put in a few White linear marks to indicate the pile of velvet fabric.

linen tablecloth

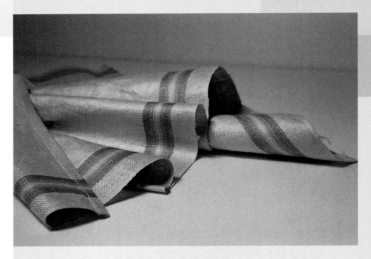

There are a few textures that are best created without burnishing. This linen cloth is a great example of one. The rough weave of the fabric distinguishes linen. Burnishing could make the cloth look too smooth. Letting the grain or white of the paper show through the pencil layers imitates the look of the linen beautifully. You could combine this rough texture with burnished textures in the same picture. The idea is to use the technique which best gives you the texture you need. This demonstration is also a good exercise in using a full range of values to create a light subject. You don't have to stick to all light and medium values to render a light object.

materials

Prismacolor Pencils

Beige · Black · Deco Aqua · French Grey 90% · Indigo Blue · Light Umber · Parrot Green

Other

Mounting putty · Strathmore 500 Series regular suface illustration board

1 Begin Contouring the Cloth

Using illustration board with a slightly rougher texture will help create the texture of the linen cloth. Drawing paper comes in several weights, but illustration-weight board accepts lots of pencil and is great for either burnishing or creating a texture.

Because the linen cloth is a light beige, you do not want your graphite pencil lines to show from your original drawing. Begin by tracing around the pencil drawing with a very sharp Light Umber. Draw alongside the graphite line, not over it. Then erase the graphite. Draw the green stripes in the same manner with Parrot Green.

Begin the cloth's contours with a light layer of Beige. Use the side of a very sharp pencil and light pressure. The side hits the hills of the grain of the paper, leaving the valleys white, which is what you want for this linen. Use the multidirectional stroke to get a nice even layer of color. Fade the color out into the white highlight areas of the folds. Take the Beige right over where the green stripes will go.

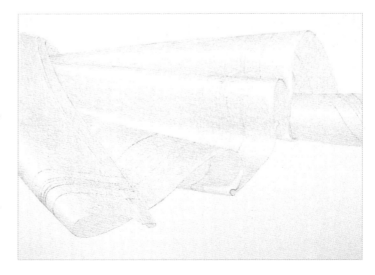

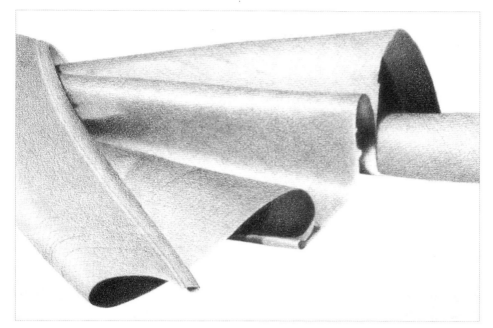

2 Add the Shadows

With the side of the pencil and medium pressure, apply a dense layer of Light Umber over the green stripes that you can just see in the shadows created by the folds at the ends of the cloth. Use Parrot Green over that for the green stripes. Apply French Grey 90% over the darkest areas. Put another layer of Beige in the exact same places and manner as Step 1 to darken the first Beige areas.

Further shape the folds with Light Umber, going over the green stripes with a sharp point and the side of the pencil, light pressure and multidirectional stroke. Fade the Light Umber into the Beige. Stroke in two diagonal directions with a very sharp Beige and the Light Umber to apply the weave of the fabric. Don't do it everywhere, just towards the end of the cloth in each fold to suggest the lines of the weave.

Place a light layer of French Grey 90% to the darkest areas of the folds, fading into the Light Umber.

3 Add the Green Stripes

Create the light green stripes on either side of the small center clear stripe with Deco Aqua. Use the point of the pencil, being careful not to fill in all of the paper grain. Do the large green stripes on the outside with Parrot Green. Stroke along the length of the stripe with light pressure. Go back over it, stroking horizontally. Apply Parrot Green lighter in the highlight areas. Darken the stripes' shadow areas first with Indigo Blue, with a little Black over it in the darkest areas. Lightly tap a piece of mounting putty over the highlight areas to lighten them. Finally, put a little Indigo Blue in the dark shadow areas under the folds to tie the shadows and stripes together.

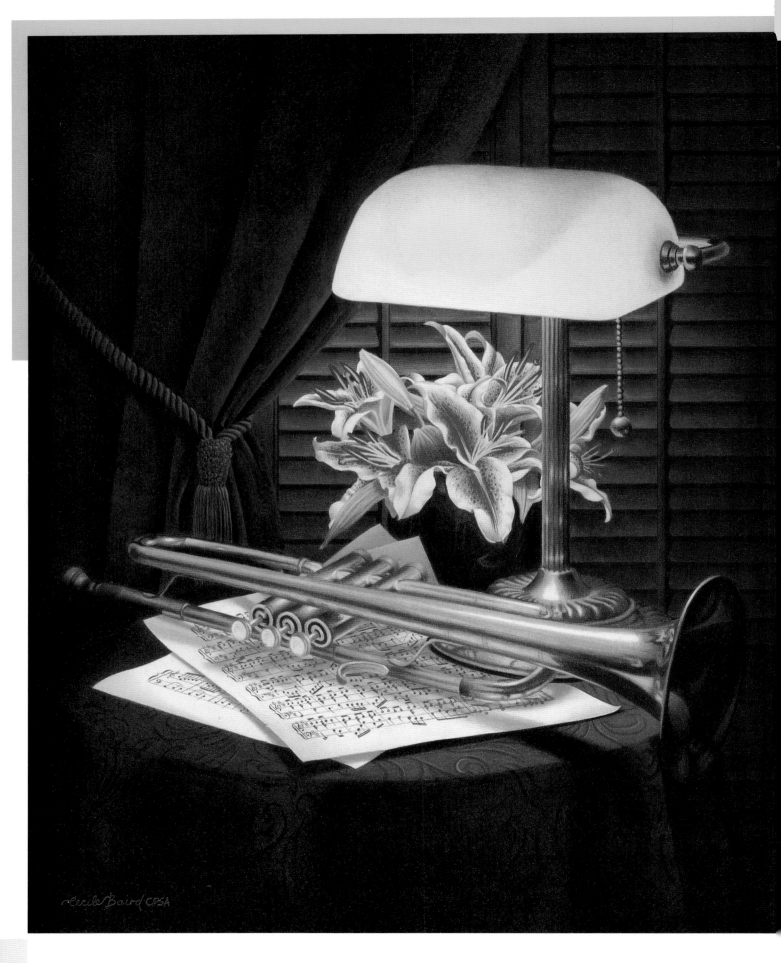

PAINT THE TOTAL PICTURE

You've learned to make use of texture, color, shape repetition, light reflections and shadows in your paintings. You've learned that breathing life into your paintings is possible with colored pencils, from the glowing kiwi to the translucent orchid to candlelight, glass, water, wood, brass and velvet. Now you are ready to apply all you've learned to create a complete picture. I will guide you step by step through two full paintings. These capture the versatility of colored pencils and show the richness and luminosity that can be achieved.

Follow along with the step-by-step demonstrations to learn how to tie the techniques and elements together to create exciting paintings that glow.

Prelude
Colored pencil on cream Stonehenge paper
16" × 12" (41cm × 30cm)
Collection of the artist

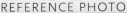

STEP-BY-STEP demonstration
combine textures
in soft light

This type of still life is traditionally painted with oils, but colored pencil is more convenient. People very often mistake colored pencil paintings like this for oil paintings.

This still life incorporates deep darks and bright highlights; a variety of textures from rich velvet to shiny brass; and a wide range of subjects from sheet music to flowers. The solvent method, as described on page 39, will save you time when applying the base color for a large portion of the painting.

materials

Prismacolor Art Sticks
Burnt Ochre · Dark Green

Prismacolor pencils
Apple Green · Black · Burnt Ochre · Canary Yellow · Chartreuse · Cream · Crimson Lake · Dark Green · Deco Yellow · French Grey (10%, 20% and 30%) · Goldenrod · Grass Green · Indigo Blue · Lemon Yellow · Limepeel · Neon Yellow · Salmon Pink · Spanish Orange · Spring Green · Sunburst Yellow · Terra Cotta · True Green · Tuscan Red · White · Yellow Ochre

Verithin Pencils
Black

Other
Battery-powered eraser · Colorless blender · Craft knife · Cream Stonehenge paper · Sanford Colerase or another set of erasable colored pencils · Small, medium and large flat brushes, ¼-inch to ¾-inch (6mm to 19mm) · Solvent · Tracing paper

REFERENCE PHOTO

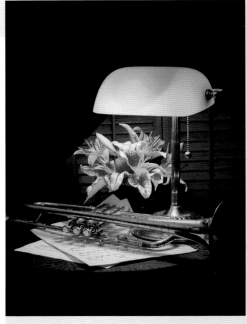

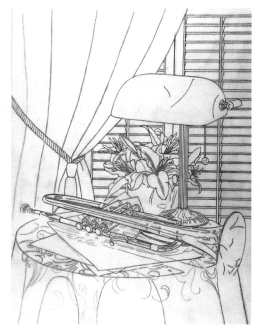

TRANSFER YOUR DRAWING
Use erasable colored pencils to transfer your drawing to drawing paper. The set I use comes in 24 different colors. Draw over each object on the back of the drawing with a color similar to the color of the object. Then when you transfer the drawing, you have a color that will readily blend.

1 Apply and Blend the Base Colors

Use medium pressure and the multidi-rectional stroke to put in dense layers of base colors for the curtains, tablecloth, lamp shade and shutters. This layer of color doesn't have to be perfect because you'll blend it with solvent and layer color over it.

Use the Burnt Ochre pencil and art stick for the shutter areas. The art sticks are perfect for large areas. The pencils better suited for smaller spots. Use Neon Yellow for the lamp shade and the Dark Green pencil and art stick for the curtain and side of the tablecloth. Don't fill in the tassel and cord. Because the tabletop is much lighter, apply a less dense layer of color with the Dark Green pencil only.

Blend With Solvent Use a series of flat brushes from about a ¼" (6mm) in the small areas to ¾" (19mm) in the large areas. Let one color dry before putting solvent on the adjacent color. Use the edge of the brush to go around the edges of each area then switch to the side of the brush for the rest of the area. A circular motion with medium pressure works best. Use the large brush as soon as you can; it works bet-ter and faster. Fill in the drape cord with your sol-vent brush.

You will get a mottled look with the sol-vent, but you'll obscure any imperfections as you continue to layer color.

SHARPEN YOUR ART STICKS

Use a craft knife to cut off the square corners of the art stick to form a point on the end. This will be easier to use.

2 Define the Folds and Shadows

Using the same colors and techniques used for the velvet drape, define the more gentle folds on the side of the tablecloth. Because light is shining on the top of the table, the side of the cloth is shadowed so the folds are more subtle than the drape's.

Apply a layer of Dark Green over the entire top of the table. Define the shadows with Tuscan Red, Indigo Blue and Black. Fade the table into the drape where it is in shadow in the back. Let the shadow fade as it comes around the table from left to right. Cover the light right side of the table with True Green over the Dark Green.

Indigo Blue over Tuscan Red

Dark Green and final Black layers

First Tuscan Red layer

VELVET DRAPE DETAIL

With a sharp point, medium pressure and multidirectional stroke, apply a dense layer of Tuscan Red—green's complementary color—in the darkest, deepest areas of the folds, fading it into the lighter areas. Apply Indigo Blue over that the same way, letting it fade beyond the red. Apply Dark Green over both colors as well as the remaining green areas of the curtain.

Deepen the shadows over the lighter folds and in the deep shadows with Black, fading it into the lighter areas. Densely layer Black in the deep parts of the folds that are more in shadow and lightly layer it over the rest to separate the lit area of the curtain from the folds in shadow. Darken the folds as they move away from the light. Lightly apply True Green to emphasize where the light hits the edges of the folds. Use the same colors for the cord and tassel, then add True Green to highlight the twists and details.

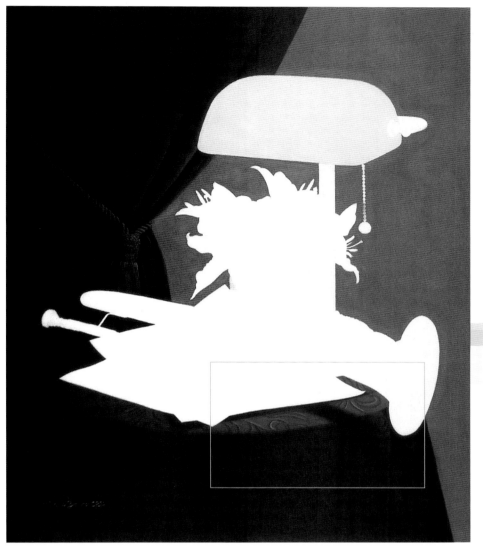

3 Create the Brocade Pattern
Use Black and a dull point to draw the tablecloth's pattern. This will let you draw the design with a single stroke. Press harder in the darker areas. On the front of the cloth apply the design only towards the top where the light spills slightly over the edge of the table. Let the design fade out into the shadows. Because the design is raised, hit the edges with a White pencil where the light hits.

GET SMOOTH EDGES

When using the pencil around the edges of flowers, dip your sharp pencil point into a little solvent and then draw. This will give you a nice smooth edge.

BROCADE PATTERN DETAIL

1 Layer Tuscan Red, then
Indigo Blue and Black for
shadows between slats.

2 Apply Terra Cotta over all
the shutters, leaving the
shutter shadows.

3 Define the shading and
shadows with Tuscan
Red.

4 Apply Indigo Blue
over the red.

5 Add Black for the
darkest shadows.

4 Define the Shutters

Follow the progression detailed above to define the shutters. Use a sharp point and medium pressure stroke in one direction for the shadows created by the shutters' slats.

As you define the shading where the slats tilt, remember that the front of each slat should be the lightest value as they fade from lighter where the lamp shines on them, to darker, where they recede into the shadows. The slats directly under the light do not need any Black. The Terra Cotta layer goes on very smoothly, but each layer after that creates a grainy effect. Burnish the darkest areas with Tuscan Red and the areas with no Black with Terra Cotta. Stroke a little Salmon Pink on the bottom edge of each slat directly under the lamp. Then cover the slats with a light layer of Sunburst Yellow to pick up the warm glow of the lamp light and draw a crisp Deco Yellow highlight on them.

KEEP YOUR EDGES STRAIGHT

Use a ruler and a very sharp pencil point to draw the lines for objects with very straight edges, such as shutters.

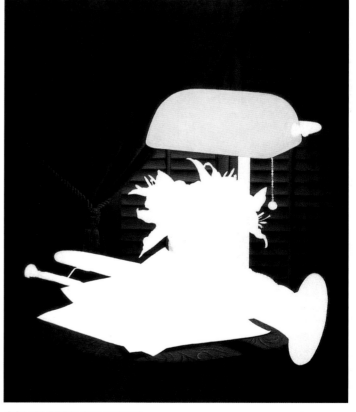

COMPLETED SHUTTERS

5 Begin the Brass Lamp and Trumpet

Use a sharp point, light pressure and the multidirectional stroke in the larger areas and the single-directional stroke in the small areas. With Burnt Ochre define all of the reflections you see in the lamp and trumpet. Apply Tuscan Red over that in areas where there are dark reflections and shadows. Cover the rest, except the white highlights, with Yellow Ochre.

PROTECT THE BACKGROUND

Cover the dark background areas with scrap pieces of paper to avoid dragging your hand over them while working on other areas. Just check regularly that no color or eraser dust is getting under the paper.

6 Finish the Brass

Put a layer of Indigo Blue in the dark reflections. Burnish with Tuscan Red, then reapply Indigo Blue. Add Dark Green to the areas where the cloth is reflected.

On the lighter shapes inside the bell use Terra Cotta, Burnt Ochre, Tuscan Red, Indigo Blue and Spanish Orange. Cover the light reflections in the bell with Deco Yellow, then Spanish Orange.

Cover the Tuscan Red areas on the rest of the brass with Terra Cotta. Apply Goldenrod on the midtone reflections. Stroke Spanish Orange (which is really a yellow) in one direction along the tubes of the trumpet with a blunt point and using heavy pressure to burnish the entire brass except for the white highlights.

In the Terra Cotta areas reapply a little Tuscan Red and Indigo Blue. Create variations in the yellow areas by stroking Deco Yellow where you want slightly lighter tones. Add Sunburst Yellow here and there for variation.

7 Begin the Lamp Shade

Cover the entire lamp shade with a layer of Canary Yellow followed by Lemon Yellow. Use a sharp point, light pressure and the multidirectional stroke. Define the green with a light layer of True Green applied in the same manner.

8 Finish the Lamp Shade

Use a sharp point, light pressure and multidirectional stroke. Start at the top of the green with Grass Green and fade that into Apple Green. Let the Apple Green fade into Chartreuse with the Chartreuse fading into the yellow. Fill in the strokes with the point of the pencil until you have a very smooth covering. On the right side where the arm fastens into the shade, add a little Tuscan Red to create a shadow. Burnish the bottom edge of the lamp with White, fading it into the yellow.

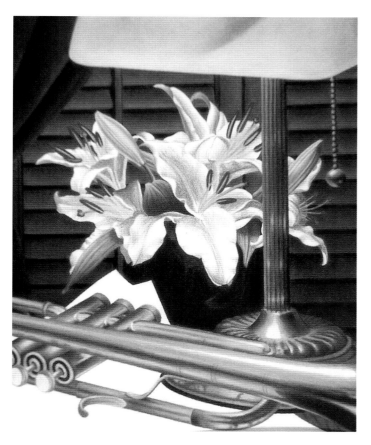

9 Create the Flower Vase and Begin the Flowers

Since the glass flower vase is completely in shadow, only a few partial reflections of the flowers show. Define these reflections using Tuscan Red over Burnt Ochre. Cover the rest of the vase with Dark Green, then Tuscan Red, leaving a few spots of the Dark Green showing through for the other subtle reflections. Burnish the vase with Dark Green.

Define the shadows and veins of the leaves and buds with Burnt Ochre, Terra Cotta, and Limepeel. Burnish all with Deco Yellow and Cream. Reapply some of the colors in the shadow areas. Add a few touches of Grass Green to the leaves. Draw the stems of the stamens with Limepeel and Cream. For the ends of the stamens use heavy pressure with Spanish Orange and Crimson Lake to fill them in one step.

Use a sharp point and light pressure to define the details of the lily petals with Goldenrod. In the darker shadows add Crimson Lake and more Goldenrod. Use a blunt point and heavy pressure, stroking in the direction of the petals to burnish all of the petals with Cream. You do not want the flowers to be as light as the sheet music in front.

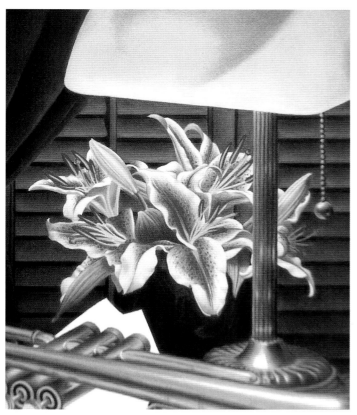

10 Finish the Flowers

Reapply the Goldenrod then Burnt Ochre to redefine the petals' shadows. To create the pink of the petals, stroke Crimson Lake down and out from their centers, letting the strokes fade toward their edges. Use a dull point with heavy pressure in the stronger color areas and lighter pressure in the lighter areas. Use the same dull point and heavy pressure to put in the dots.

11 Make the Shadows on the Sheet Music

Begin the shadows cast on the sheet music from the trumpet with Goldenrod, letting the edges fade softly onto the paper. Make the darker parts of the shadow with Burnt Ochre over the Goldenrod. Apply the colors with a sharp point and light pressure. Burnish the shadows with French Grey 30% in the darkest areas, 20% in the middle areas and 10% on the edges. So that the entire sheet music will have the same texture when you apply the notes, burnish the rest of the paper area where no color s applied with a colorless blender. Use a blunt tip and heavy pressure for all of the burnishing.

12 Finish the Sheet Music

Lay out the bars for the music on a sheet of tracing paper. Transfer the bars to the sheet music. Using a Black Verithin pencil with a very sharp point, lightly go over the bars. Then, freehand the notes onto the paper with a very sharp point. Don't worry about getting the notes correct; no one is going to play the music in your painting.

13 Finish the Painting
Apply White to the highlights and you have a completed painting!

Prelude
Colored pencil on cream Stonehenge paper
16" × 12" (41cm × 30cm)
Collection of the artist

THE LAMP SHADE IS TOO GREEN!

Once the entire painting was done, I didn't like the lamp shade. It was too green and attracted attention away from the trumpet and music. What to do? It was impossible to change the color of the green; the paper simply couldn't accept any color. The only solution was to erase the entire lamp shade and start over. I used my battery-powered eraser—and a couple of batteries—to remove the color.

If you'd like to recolor the lamp in your painting, apply the new color as follows: first a layer of Canary Yellow, fading into the white at the bottom of the shade; then add Apple Green at the top fading into Spring Green; then put Chartreuse into the yellow. Finish the shade by burnishing the lower part of the yellow with Deco Yellow fading into White at the bottom of the lamp. I think the results are better for the overall picture. It is almost never too late to alter a painting.

STEP-BY-STEP demonstration
paint light-filled surfaces with texture

Use all you've learned about light to turn an ordinary group of objects into a beautiful work of art with strong cast shadows. Even though each piece in this picture is a vase, the different textures and colors give you an opportunity to explore how light reflects on different surfaces. We'll progress through the painting one vase at a time, then tackle the bamboo mat, the background, and finally the vine.

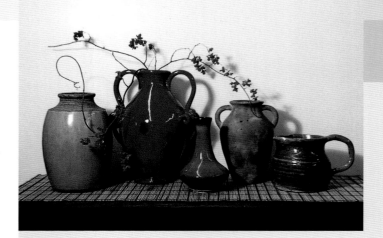

materials

Derwent Artists Pencils

Burnt Yellow Ochre · Golden Brown

Derwent Signature Pencils

Manganese Blue Hue

Faber-Castell Polychromos Pencils

Oriental Blue

Prismacolor pencils

Beige · Black · Black Cherry · Black Grape · Burnt Ochre · Cool Grey (10%, 20%, 30%, 50%, 70% and 90%) · Cream · Crimson Lake · Crimson Red, Dark Brown · Dark Green · Dark Umber · Deco Blue · French Grey (20%, 30%, 50% and 90%) · Indigo Blue · Jade Green · Light Umber · Orange · Pale Vermilion · Peacock Green · Periwinkle · Sand · Scarlet Lake · Sienna Brown · Slate Grey · Terra Cotta · Tuscan Red · White · Yellowed Orange

Verithin Pencils

Carmine Red · Cool Grey 70% · Dark Brown · Orange · Indigo Blue · Terra Cotta · Tuscan Red · Warm Grey 20%

Other

Colorless blender · Electric eraser · Kneaded eraser · Mounting putty · White Stonehenge paper

COMPOSITIONAL LINE DRAWING OF SETUP ON TRACING PAPER
Use a center line to make sure both sides of each vase, if they are symmetrical, are exactly the same. Many people overlook perspective in their still-life paintings. But if you've ever seen a jar or crock that looks lopsided in a painting, that is the result of poor perspective. Photos often distort objects, so you have to alter your drawing from the reference photo.

Once you've worked out the line drawing, use one of the methods on page 35 to transfer your line drawing to your drawing surface.

1 Apply the Darkest Colors

Begin with the red vase because its colors are so dark and staining. You can easily erase dark or staining colors from blank paper, just not from light areas that have already been covered with pencil.

Using the complementary color principle, begin the red vase by contouring and shading the vase with Peacock Green with a sharp point, light pressure and multidirectional stroke.

2 Add the Reds

Go over the Peacock Green with Tuscan Red. Then use Crimson Lake to go out from the Tuscan Red and put in the next darkest shades.

3 Complete the Red Vase

Use a blunt point, heavy pressure and the multidirectional stroke for this step. Burnish the dark Tuscan Red areas with Crimson Lake and the Crimson Lake areas with Crimson Red. Cover the rest of the vase where there is no color yet with Scarlet Lake. Leave only the white highlights. Cover the light shapes in the vase that should look pink with Scarlet Lake burnished with White. Don't put white highlights on anything until the very end, though. Reapply a light layer of Peacock Green to the dark areas. Use sharp Verithin pencils to go around the edges of the vase: Use Tuscan Red in the dark areas and Carmine Red on the rest. Cover the reflection in the deep shadow on the bottom right side, first with White then Cool Grey 50%.

The red turns the surrounding paper light pink. It's nearly impossible to avoid this. You can easily erase it with a kneaded or electric eraser.

4 Begin the Blue Crock

Cover the blue part of the crock with Slate Grey. Use a blunt point and light pressure to skim the pencil over the top of the paper to create the grainy effect. Use Sienna Brown to define the unglazed terra cotta top and bottom of the crock, then increase the pressure to lay in the ridges on the top section.

5 Add the Shadows and Texture

Cover the entire unglazed top section with a light layer of Beige. Touch the ridges with Sienna Brown and Terra Cotta so that it looks rough and uneven. Finally, with a very sharp Black Grape put in the darks, emphasizing the ridges. Fill in the bottom strip with Terra Cotta and Black Grape.

Put in the shadows on the blue glazed body with Black Cherry covered with Sienna Brown. Use a sharp point and the multidirectional stroke, making it darker on the right and letting it fade as it goes toward the center. Go over the Black Cherry and Sienna Brown with Cool Grey 90% in the darkest areas and Cool Grey 70% in the next darkest areas, letting it fade out. Also touch the Black Grape on the top and bottom with the Cool Grey 90%.

Apply a layer of Periwinkle over the body of the vase using a very sharp point, light pressure and the multidirectional stroke.

6 Complete the Blue Crock

Use medium to heavy pressure to apply a dense layer of Jade Green to the body. Leave the white highlights. Burnish the entire body except for the highlights with Cool Greys. Use 10% around the white highlight, then blend 20%, 30%, 50% and 70% as you go around the crock. Apply a light layer of the 90% burnished with 50% for the darkest shadow.

Add a little more Cool Grey 90%, then Black Grape to the crock's bottom. Add the red reflection from the red vase on the upper right side with Crimson Red burnished with Cool Grey 20%. Be as sharp as you can around the vine and berries, but don't worry if they are not perfect now. Go over the right and left edges of the blue body with a very sharp Verithin Warm Grey 20% to finish.

7 Begin the Small Blue Vase

Use the side of your pencil to skim over the surface of the paper with Black Cherry to cover the entire vase—except for the white highlights—with a rough layer. This begins the look of speckled glaze. Put in the shadows with Indigo Blue covered with Black Cherry. Put in the top rim with Black Grape, Indigo Blue and Terra Cotta. Do the same on the bottom except fill in the small area along the bottom edge where there is no glaze with Beige.

8 Burnish the Small Blue Vase

Use a blunt point, heavy pressure and the multidirectional stroke to burnish the dark areas with Faber-Castell Polychromos Oriental Blue and the rest of the vase with Derwent Signature Manganese Blue Hue. Leave only the white highlights. Pick out the light blue highlights with Deco Blue. For the base and top rim use Black Cherry, Tuscan Red and Terra Cotta.

9 Finish the Shadows and Glaze

Apply a light layer of Tuscan Red and Indigo Blue to the shadows. Then burnish with the same, first the Tuscan Red, then Indigo Blue for rich dark shadows.

Use the side of your pencil to reemphasize the speckled glaze by going over the blue, except for the highlights with Tuscan Red and Black Cherry. Touch up the bottom and top with the same colors you used in Step 8.

Tuscan Red+Dark Green+
Tuscan Red+Indigo Blue Burnt Ochre

Jade Green+Slate Grey

Indigo Blue Beige + Sand

10 Apply Color to the Clay Pot

Because this pot has a porous clay surface, the grain of the paper should show through the color. Use a sharp point and light pressure to achieve the splotchy appearance. Cover the entire pot with a light layer of Beige. Scatter Sand over parts of the pot leaving the Beige showing to create the lightest splotches. Next apply Burnt Ochre in the shadow areas and around the handles and rim as well as small areas over the whole pot.

Put in splotches of Jade Green and Slate Grey. Apply a light layer of Indigo Blue over some of the Slate Grey to create a few bluer areas. Go over the shadows with Tuscan Red, then Dark Green, then Tuscan Red again, and finally Indigo Blue.

11 Burnish the Clay Pot

Burnish the entire pot with a colorless blender using a blunt point and only medium pressure so you can still see the texture of the pencil. To sharpen the edges use very sharp Verithin Indigo Blue and Terra Cotta pencils.

12 Begin the Glazed Pitcher

Use a sharp point, light pressure and the multidirectional stroke to cover the entire pitcher except for the white highlights with a light layer of Beige. Let the grain of the paper show through to capture the speckled glaze. Apply a layer of French Grey 30% over that in the same manner. Define the shadows and ridges around the pitcher with French Grey 50%. Finally, with a blunt point burnish the whole pitcher with a colorless blender. It only requires a medium to heavy pressure, since there is not a lot of color. Because the speckles on this glaze are dark over a light base, it will not be possible to burnish after you apply them. The burnishing would blend the dark into the light eliminating the speckles and creating new pastel colors that you don't want.

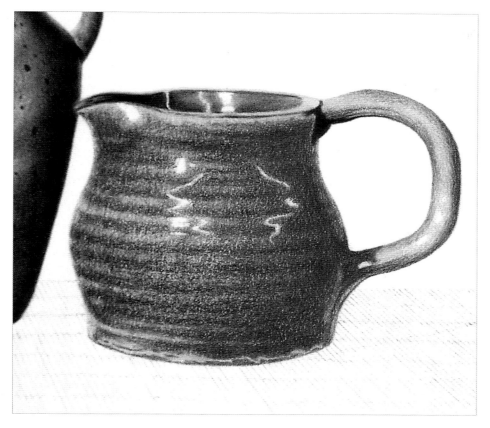

13 Develop the Pitcher's Shadows

Continue to define the ridges and shadows of the pitcher with French Grey 90%. To keep the speckled look, use the side of your pencil to lay down the color. Press harder in the darker areas. In the dark shadow areas fill in the grain with the point of your French Grey 90%. The speckles don't show in the shadows and this will help deepen them. Begin to add Dark Umber, Tuscan Red and Indigo Blue to the darkest areas, such as where the handle meets the body.

On the inside of the pitcher add Tuscan Red, then Indigo Blue and blend them with a colorless blender. Put Burnt Ochre and Terra Cotta around the top rim.

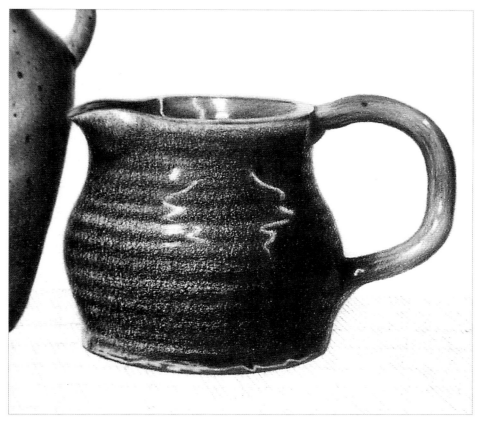

14 Add Color to the Speckles and Deepen the Shadows

To add color to the speckles, layer first Dark Umber, then Tuscan Red, followed by Indigo Blue mainly on the ridges and in the shadows. Apply all three colors with the side of your pencils letting them skim across the top of the paper to create the speckled look. Fill in the dark areas again with the sharp point. The shadows still aren't dark enough, so cover the darkest areas with a light layer of Black, then Tuscan Red. Repeat the two colors until you achieve the desired dark.

Finish the unglazed bottom section on the pitcher with Tuscan Red burnished with Terra Cotta. On the dark parts of the handle, which is not speckled, lay in Dark Umber, Tuscan Red, and Indigo Blue and burnish with a colorless blender. Then add Terra Cotta where needed. Go over the edge with Cool Grey 70% and Warm Grey 20% Verithin pencils to make a nice sharp edge.

Define dark reeds
with Dark
Umber+Burnt
Ochre+Terra Cotta

Define shadow with
Dark Umber+Slate
Grey+Cool Grey (50%
and 70%).

Randomly stroke in
Burnt Ochre, Cream,
Light Umber, Sand
and Derwent Artists
Burnt Yellow Ochre
and Golden Brown.

Add Sand.

Begin stitching and
lines with Dark
Umber.

CREATE THE BACKGROUND

Use Verithin Dark Brown and Orange pencils to
go over your graphite lines on the vine so that
they won't smudge. You'll finish the vine after
you're done with the background.

To achieve the look of the slightly textured
off-white wall in this painting, apply a light layer
of Cream over the entire background, even
where the shadows from the vases will be. Use
a blunt point, light pressure and the multidirec-
tional stroke. Just let the pencil skim across the
top of the paper as you have in several of the
vases in this piece. As a final touch I dabbed
a piece of the sticky mounting putty randomly
over the background like a faux finish rag
technique.

15 Create the Bamboo Table Mat
With a sharp Dark Umber, draw the spaces between the bam-
boo and the rows of threads. Use a sharp point, light pressure and a
single stroke along the bamboo to cover it with a light layer of Sand.
To create the color variations, randomly stroke in the bamboo reeds
with: Burnt Ochre, Cream, Light Umber and Sand; and Derwent
Artists Burnt Yellow Ochre and Golden Brown. Burnish these with
Cream and Sand and reapply the colors. Define the dark reeds with
Dark Umber, Burnt Ochre and Terra Cotta.

With a very sharp point, darken the lines between the bamboo and
the rows of stitching with Dark Umber. Fill in the shadow areas with a
layer of Dark Umber. Then stroke on Slate Grey and Cool Grey 50%
and 70% over the Dark Umber. Burnish them all with a colorless
blender.

Cool Grey 20% + Cool Grey 30%

Slate Grey

Crimson Red + Cool Grey 50%

16 Add the Shadows

All the shadows begin with Cool Grey 20% and 30%. They have soft edges, so apply them freehand rather than transferring them from your drawing. Using a sharp point, light pressure and the multidirectional stroke, apply a light layer of Cool Grey 20% letting the edges feather out into the background. Put down a layer of Cool Grey 30%, letting it fade into the 20% toward the edges. In those shadows surrounded by background, start the 30% in the middle and work toward the edges.

Add a third layer of Slate Grey to the shadows for the red vase, blue crock and small blue vase.

Add a layer of Crimson Red to the red vase's shadow, then a slight amount of Crimson Red to the blue crock and small blue vase shadow. Finally, add a layer of Cool Grey 50% to all the shadows.

Add Cool Grey 90% to the shadow of the blue crock on the left and the bottom shadow of the red vase next to the table, since these shadows are darker. Add Cool Grey 70% to the small blue vase shadow.

17 Burnish the Shadows

Use a blunt burnishing point and heavy pressure to burnish the upper shadow on the red vase with Cool Grey 30%. Burnish the bottom shadow of the red vase and the blue crock with Cool Grey 70%. Burnish the small blue vase shadow with Slate Grey. Also apply a little Cool Grey 90% over the mat shadows to make them equal to the vase shadows.

18 Complete the Shadows

For the shadow of the clay pot layer Cool Grey 50% then French Grey 50% over the Cool Greys 20% and 30% already down. Then add a layer of Jade Green over the French Grey. Burnish all of this with French Grey 20% and 30%.

To finish the shadow of the glazed pitcher on the right add a layer of Slate Grey followed by a slight amount of Crimson Red. Then burnish it all with Cool Grey 30%.

Add a very light amount of Slate Grey and a touch of Crimson Red to the vine shadows and burnish with Cool Grey 10% and 20% around the edges to soften them into the background. Go over the edges of all of the shadows with the Cool Grey 10% and 20% to soften them into the background as well. The shadows of the red vase need to be quite red, so go back into those shadows with a little Crimson Red and burnish them with the Cool Greys.

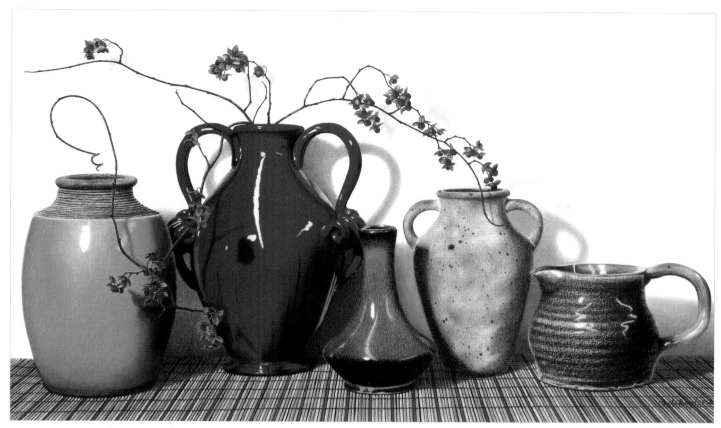

19 Complete the Vine and Berries to Finish

Fill-in the vine with a dense layer of Derwent Artists Golden Brown using medium pressure and a very sharp pencil. This will make the darker brown colors go on smoother. Follow this with a light layer of Burnt Ochre, then Dark Umber. Stroke Sand and Cream over the Dark Umber to create the vine's lighter areas where the light hits. This little bit of variation gives the vine depth and dimension.

Apply the berry colors with a sharp point and heavy pressure in order to get lots of color in these tiny shapes quickly. Cover the berries with Crimson Red, then contour and shade them with Crimson Lake and Tuscan Red. Put in the pods that pop open around the berries with Pale Vermilion, Orange, and a little Yellowed Orange. Touch Crimson Red and Crimson Lake in the darker areas of the pod. In the lighter areas use Cream. In the few places where you need darker shadows on the berries or pods add Indigo Blue with Tuscan Red on top.

Burnish the white highlights with White to complete!

Vases and Vines
Colored pencil on white Stonehenge paper
10"× 16" (25cm × 41cm)
Collection of the artist

Conclusion

So now you've seen and experienced for yourself the rich, painterly results possible with colored pencils. I hope you've used this book as a workbook, following the step-by-step demonstrations. Through them, I hope you've begun to appreciate the versatility, precision and convenience of this wonderful medium.

Remember, the goal is not necessarily for you to re-create these paintings exactly as they appear here. Your goal is to master the techniques used to create these paintings. Then use those techniques for your own creations. Play with the light in your still-life setups. Use dramatic darks to enhance the lights as you place them in your paintings and make them glow. Layer! Layer! Layer! Then burnish those layers to get the rich look of oil paintings without the expense, mess or inconvenience. Lastly, be patient. Investigate the world around you, then enjoy the journey as you turn that world into art.

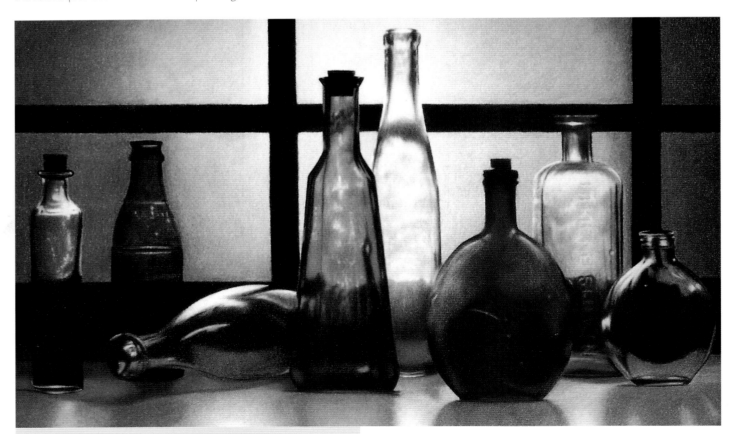

Bottled Twilight
Colored pencil on Strathmore 500 Series, regular surface
15" × 21" (38cm × 53cm)
Private collection

Index

Acetate, 28, 33
Apple, 54-57

Background, 49, 60-61, 63, 66-7, 87, 122
 dark, 58
 protecting, 109
Backlighting. *See* Lighting
Balance, 16-18
Bamboo mat, 122
Blender, colorless. *See* Colorless blender
Board, watercolor backing, 28
Brass, 109-111
Bronze, 77
Brushes, 31, 39
Burnishing, 29, 37-8, 43
 with white, 59

Candlelight, 14, 19, 33, 72-8.
 See also Lighting
Cantaloupe, 8, 17-18, 51-3
Cast iron kettle, 90-92
Center of interest. *See* Focal point
China marker (White), 78, 92
Cloth. *See* Fabric
Color, 12-13, 18, 40-45.
 See also Green; Value
 complementary, 16, 43-5
 layering, 37, 43, 87, 126.
 neutrals, 43-4
Color lifters, 31
Color wheel, 43
Colored pencils, 29-30, 36-8
Colorless blender, 31, 37-8, 43, 75, 90-91
Composition, 11-18, 34
Contour, 44-5, 69, 94
Contrast, 16, 19, 22, 40
Copier method, 32
Copper cup, 88-9
Craft knife, 30-31
Crockery, 34, 40, 45, 54-7, 114-125

Daisy, 44
Depth, 16-20
Details, 44
Drawing surface, adjustable, 31
Dust, pencil, 80

Edges, 107-8
Erasers, 30-31

Fabric, 19, 46-7
 linen, 100-101
 velvet, 98-9, 106-7
Fixative, 31, 38, 65
Flowers, 19, 23, 44, 46-7, 58-65, 111.
 See also Leaves; Plants

Focal point, 16, 18, 40
Fruit, 5, 8, 12-18, 25, 40-2, 44-57

Glass, 76-81
 cobalt blue, 79-81
Glow. *See* Luminosity
Grapes, 8, 17-18, 41-2
Green, 69-71, 113
Grid method, 32

Harmony. *See* Balance
Highlights, 19, 51, 54, 70-71, 75-6, 80, 95

Illustration board, 100

Kettle, 16, 90-2
"Kissing," 18, 54
Kiwi fruit, 14, 48-50

Leaves. *See also* Flowers; Plants
 autumn, 13, 66-68
 green, 69-71
Lifting, 31
Lightbox, 35
Lighting, 12, 14, 17, 19-23, 25.
 See also Candlelight; Sunlight
 artificial, 20-21
 backlighting, 14, 18, 20-21, 48
 front, 20
 natural, 22
 soft, 104-113
Line drawing, 32-3, 114
Luminosity, 14, 18, 43, 47, 63, 65, 75, 103, 108, 126

Markers, 31, 78, 92
Melon. *See* cantaloupe
Money plant, 20, 26-7, 58-9

Nails, 97
Neutrals, 43-4

Oil lamp, 14, 76-8
Orange, 44
Orchid, 46-7, 60-62
Overlapping, 16, 18

Paper, 28, 35, 76
Pencil drawing, 58
Pencils
 colored, 29, 36-8
 graphite, 35
 mechanical, 31
 storage of, 30
Perspective, 16-18, 34, 114
Photographs, 16, 22, 24-5
 drawing from, 34

Pitchers, 7, 13, 25, 86-7, 114, 121
Plants, 34. *See also* Flowers; Leaves
Point of view. *See* Perspective
Pottery. See Crockery
Projector method, 32-3
Proportional scales, 33
Putty, 31

Reflection, 12, 16, 22, 76, 80, 82-3, 87-8
Repetition, 12-13, 16
Rose, 19, 63-65
Rulers and straight-edges, 31
Rust, 90

Sandpaper, 30
Shadow, 12, 14, 16-19, 21, 44-5, 48-9
 secondary, 20-21
Shapes, 12-13, 18, 93
 abstract, 79, 82, 84
Sharpener, 30, 36
Sheet music, 112
Shells, 12, 93-5
Shutters, 16, 108
Silver dollar plant. See Money plant
Solvent, 31, 39, 55, 107
Space, empty, 16
Still life, 12-18, 25, 47, 126
Strokes, pencil, 36
Sunlight, 22-3, 63. *See also* Lighting
Surfaces, 87
 dull, 87, 90-92, 96-7
 shiny, 54-7, 87-9, 97
 smooth, 93-5

Tape, 31, 60
Texture, 12, 17, 52, 100, 114
Tiles, 82-3
Tools, 27-31
Tracing, 28, 35
Transparency, 58, 82-3, 87
Trumpet, 104, 109-111

Value (color), 16, 18-19, 40, 100.
 See also Color
Vases, 16, 111, 114-120, 123-5
Vines, 114, 117, 125

Water, 82-5
Water fountain, 84-5
Wax bloom, 29, 31, 38, 59, 65
Wood texture, 96-7

 Master the art of colored pencil with these fine North Light Books!

Colored Pencil Solution Book
Tips and techniques for winning results
Janie Gildow & Barbara Benedetti Newton

Just follow the step-by-step demonstrations to achieve the subtle contours of a rose, weathered wood, a rough orange rind, shiny hood ornaments and more than 80 other textures, including: leaves, fir, palm, fern, cactus, bark, sand, gravel, soil, rock, water; hair, skin, fur, hide, scales, feathers, glass, porcelain, metal, brick and wicker.

ISBN 0-89134-653-8, hardcover, 128 pages, #30775-K

Questions about color? In a quandary about composition? Want to know how to make glass sparkle? Find answers to 70 of the most common colored pencil questions along with shortcuts, creative advice and step-by-step techniques that will make a huge difference in your art.

ISBN 1-58180-026-6, hardcover, 128 pages, #31672-K

These and other fine North Light books are available at your local art store, bookstore, online supplier or by calling 1-800-448-0915.

Anne deMille Flood shares her easy techniques for rendering cats, dogs, birds, horses and other animals with 20 step-by-step demonstrations.

ISBN 1-58180-409-1, Paperback, 128 pages, #32579-K

In this ultimate reference book for artists Lee Hammond shows you how to make your work more lifelike and realistic with concise step-by-step instuctions and basic techniques. Lee's book covers all subject matter and details how to draw still life objects, landscapes, plant life, water and skies, as well as transparent glass, metallic surfaces, bricks and fabric.

ISBN 1-58180-587-X, Paperback, 160 pages, #33058-K